creative drawing and illustration

creative drawing and illustration

a sourcebook of inspirational drawing skills

Peter Gray

ARCTURUS

About the author
Peter Gray is long established as an illustrator of
books, magazines and newspapers, with occasional
forays into such fields as film storyboards and
costume design, advertising and animation
projects. Peter is also the author of many books
for adults and children, which have been
published in many languages all around
the world.

Dedicated to Anthony Matthews; an inspiring artist and friend.

ARCTURUS

This edition published in 2011 by Arcturus Publishing Limited
26/27 Bickels Yard, 151–153 Bermondsey Street,
London SE1 3HA

Text and illustrations copyright © 2011 Peter Gray
Design copyright © 2011 Arcturus Publishing Limited

ISBN: 978-1-84837-842-1
AD001663EN

Printed in Singapore

Contents

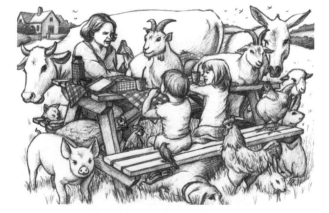

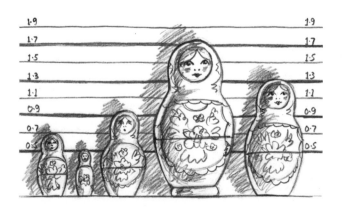

Part 1
INTERPRETATION

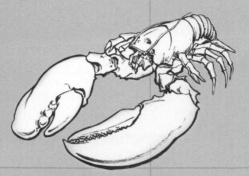

To be able to draw is very rewarding, for there are few thrills to match those almost magical moments when some quick strokes of the pencil produce a convincing depiction of three-dimensional reality. At such times, all the early struggles and failures that you have to go through to reach that point become worth while.

Once you have mastered the basic skills it may be tempting to continue drawing traditional subjects such as flowers and teapots, each time replicating the thrill of getting it right – but there is no reason why aspiring artists should not aim a little higher and strive to make their drawings more impressive. This does not necessarily mean more complicated – indeed, the opposite may very well be true – but a little thought can go a long way towards turning run-of-the-mill academic studies into artistic statements of impact and intrigue.

So, in the first half of this book, we shall look at the devices you can employ to bring the best out of your drawings of the world around you. To start with we shall examine the benefits of carefully selected viewpoints to add interest to your compositions, then we shall investigate the various materials and techniques that will further enhance your range of expression.

You should soon find that your drawing skills develop into whole new realms of possibility, but this is only the beginning. We shall move on to more and more inventive approaches that will encourage you to manipulate your subjects in all manner of ways, gradually leaving behind any tendencies you may once have had to render the world like a mere camera does. The aim is to bring out the artist in you, and an artist bends the world to his or her will.

For sharpening your skills and developing your eye, there is no substitute for drawing directly from a real-life subject. Ordinarily I would not advocate drawing from photographs, but because of the imaginative nature of this book some of the subjects and techniques depend on them. Ultimately, all that matters is the finished image, and the route is unimportant. However, if you want to become a fully rounded artist, I recommend that you draw from life wherever possible.

Subject Matter

Do you remember, when you were a child, wanting to make a picture but being unable to decide what to draw? Perhaps you are still plagued by the same frustration. However, the solution is so often to be found right in front of you. In learning to see and think like an artist, you will discover that fascinating subjects reveal themselves at every turn.

It could be said that there is no subject unworthy of your attention; an artist will find something interesting in the most mundane of surroundings. That may well be true, and I hope that this book will point you in precisely that direction, but you can also give yourself a head start by seeking subjects that are interesting of themselves. You can practise drawing a conventional subject such as flowers in a vase, or hone the same skills by drawing weeds thrusting out of cracks in a wall. I know which picture I would more enjoy looking at.

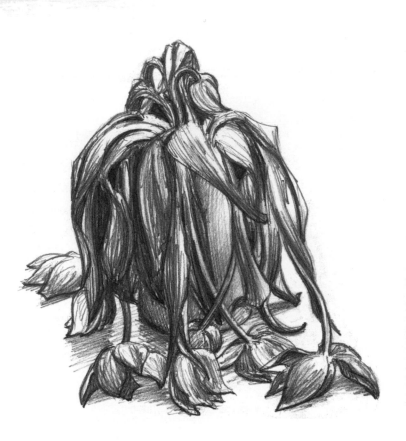

▲ Essentially this is nothing more than a typical academic drawing exercise, but because these flowers are wilted and dying, it avoids the usual prettiness of the subject and subverts the cliché. It can be a lot of fun playing with artistic conventions.

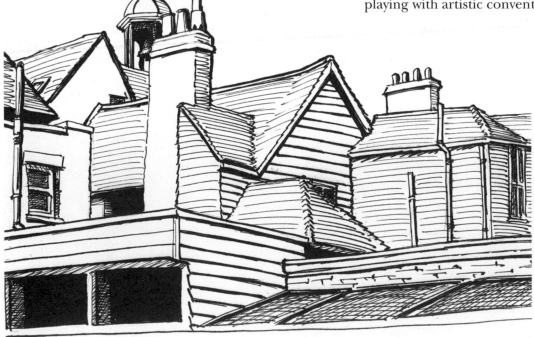

◀ Often the most interesting aspects of a scene are to be found by looking above the everyday life of street level.

▶ With a subject as immediately striking as this mummified cat you can hardly go wrong. There is nothing stylish about this sketch (done in a museum), but the subject matter makes the viewer want to know more.

▲ Look out for spontaneous moments and be prepared to act quickly. This blackbird made a habit of perching atop a garden ornament. She never hung around for very long, but I was waiting for her with sketchbook in hand.

▶ There is much mileage to be had from irreverent, humorous or even vulgar subjects.

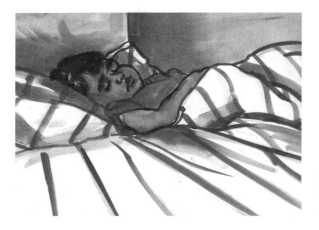

◀ A subject of innocence and beauty will always be a joy for the artist and the viewer.

Viewpoints

Part of the role of an artist is to examine different ways of looking at a subject rather than just accepting the obvious. The viewpoints – the angles and positions from which you choose to depict your subjects – make all the difference to the success of your drawings.

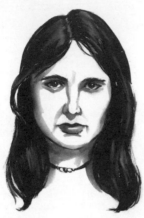

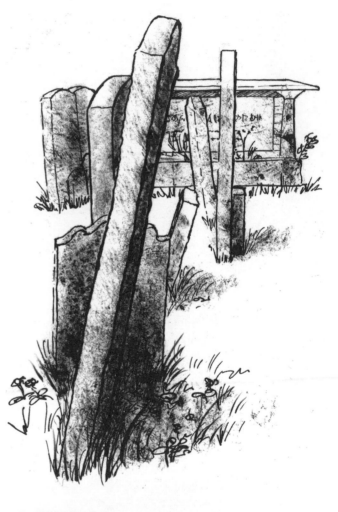

▲▼ FRONT VIEW

Human portraits drawn directly from the front usually look little more interesting than a passport photograph, however stylishly drawn or rendered, but the same viewpoint presents this sheep with a degree of symmetry that is rarely seen in these nervy, skittish creatures. This view also accentuates the mass of the fleece compared to the skinny legs and small head.

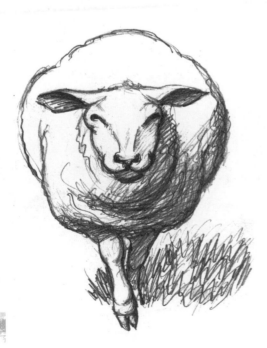

▲ PROFILE

The side view of these gravestones shows them to be leaning at odd angles, which would be less visible from other viewpoints.

▼ REAR THREE-QUARTERS VIEW

This angle gives us an unusual 'behind-the-scenes' glimpse of a seaside amusement. A view from directly behind would be confusing, but the three-quarter angle makes the scene readable.

▶ In another rear three-quarters view, the structure of this fairground sign is more noticeable than the wording, which would dominate the picture if it were legible. This is also a good angle to portray the birds' forms as it breaks up the symmetry of the front view.

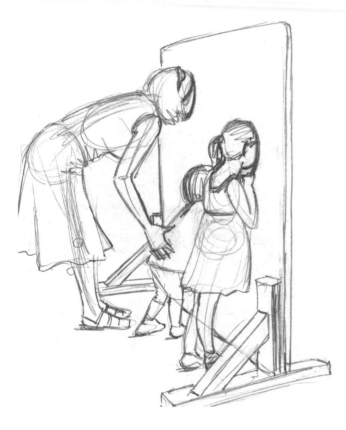

▶ REAR VIEW

This sketch demonstrates a concept that will frequently be alluded to in this book: 'less is more'. This viewpoint offers very little detail, but still conveys much about the character in a view that is not often depicted.

Looking Down

Further possibilities arise when you consider the height from which you view your subjects. It can make a huge difference to the impact of a drawing if you make the effort to look down on your subjects from above.

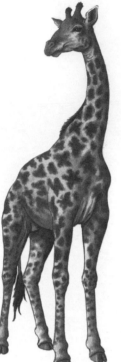

◀ This is an illustration I did for an educational book. With its level viewpoint, it objectively describes the animal's features and proportions – but it can hardly be considered an artistic statement.

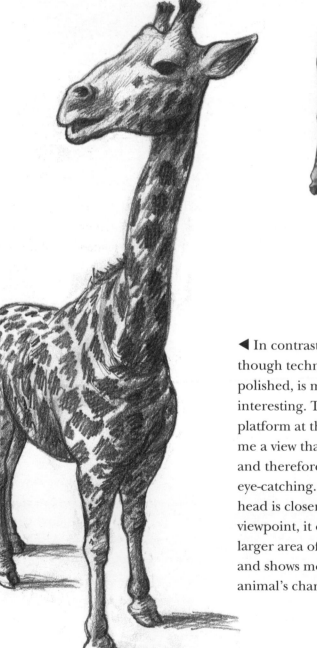

◀ In contrast, this drawing, though technically less polished, is much more interesting. The viewing platform at the zoo gave me a view that is unusual and therefore immediately eye-catching. Because the head is closer to the viewpoint, it occupies a larger area of the picture and shows more of the animal's character.

▲ For this student study I balanced a mirror across the backs of two chairs and crouched underneath, giving a view of myself from above. It is good practice for an artist to study the familiar from unfamiliar viewpoints.

▲ There are many angles in a drawing like this, but they need not be too confusing to draw. All vertical lines should be drawn strictly vertically, while other angles can be assessed with the aid of your pencil. Hold it vertically about 30 cm (12 in) in front of you, then tilt it left or right until it lines up with the object you want to draw. Holding that angle, move the pencil down to the relevant area of your page and draw the line.

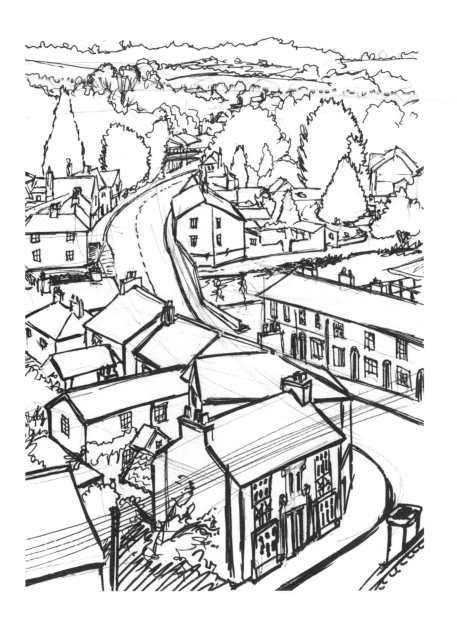

▲ The view from the top of a church tower allowed me to see parts of my town that are invisible from street level and opened up the scene into an interesting composition.

ARTIST'S ADVICE
A viewpoint looking down on a person usually has the effect of diminishing their presence, making them seem weak and subservient. This device is often employed in narrative illustration and comic books.

Looking Up

Drawing from low viewpoints may require you to crane your neck, crouch down or even lie flat on the floor to find the ideal angle for a particular piece. But you must sometimes suffer for your art, and the results will often make the struggles worth while! Low viewpoints can be especially effective for bringing interest and presence to ordinary subjects.

▶ I drew this giraffe in a museum while sitting on the floor. Notice how distant the head looks and how solid the body is compared with the example on page 12.

▲ Placing the mirror on the floor allowed me to make this rough painting as if looking up at myself. Not only is the low angle of view arresting, but it also has the effect of conveying an attitude of superiority or haughtiness.

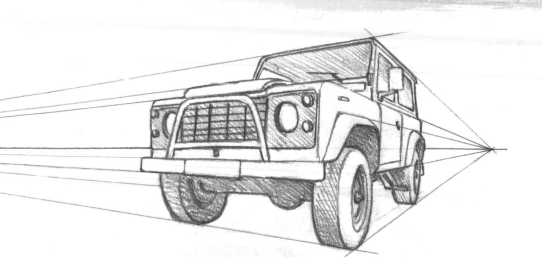

▲ The same principle applies to inanimate objects; it is not an unconscious decision that leads advertisers to depict vehicles from low viewpoints, as is often done.

Drawings such as this can be tricky to get to grips with, but a little basic perspective can help. As this diagram shows, along the eye level (or horizon) the lines remain horizontal, but all horizontal lines above and below the eye line drop away at increasingly sharp angles. All these lines converge at points on the horizon. Thus, a grid of guidelines may be drawn quite easily to assist with making such a drawing convincing.

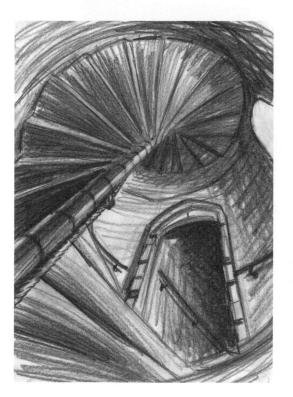

ARTIST'S ADVICE
Looking up at such sharp angles can present you with some confusing angles to draw, but again some simple perspective guidelines can help. The angle causes the vertical lines to converge at a single point overhead.

▲ To sketch this ancient staircase, I chose to look directly up to show the undersides of the steps as they spiral out of view.

Viewpoints Near and Far

Just as important as the angle and level of viewpoint in affecting the impact of a drawing is the artist's proximity to the subject. To demonstrate how great an effect this can have, consider these three views of the church and statue in a town square.

▶ From a distance, the scale of the statue is seen in its relative proportion to the church behind it and acts as a mere detail against the expanse of the church. This is a dispassionate and objective viewpoint.

◀ From a much closer viewpoint, the statue becomes more of a feature of the drawing. The distance between the two subjects is also more apparent and we feel more of a sense of involvement in the scene.

▶ From a stance near the base of the statue, the church is further diminished in relative scale and importance, appearing little more than a decorative backdrop to the dominant foreground feature.

▶ A very close viewpoint is useful for emphasizing selected parts of a subject. For this giant lobster museum exhibit, I positioned myself very close to those fiendish claws so that they seem even larger than life and really dominate the drawing.

SIGHT SIZING

With the apparent distortions of scale that come about with close viewpoints, it can be tricky to judge relative sizes accurately. To help with this, your pencil can be used as a makeshift ruler. Holding it out in front of you, measure a particular dimension of your subject and mark the length with your thumb. It should be easy to find other parts of the subject that have the same measurement from your point of view.

You can then check that the relevant proportions match on your drawings and adjust as necessary. For example, from my viewpoint, the breadth of the foreground claw here is equal to the length of the creature's main head and body section and the pincer part of the other claw.

Breadth of View

When considering the many viewpoint options for a drawing, we must also think about the possibilities presented by different breadths of view. From a microscopic detail to a vast panorama and every stage in between, how much of a scene you choose to depict has an effect on what your drawing says about a subject and how much impact it has.

ARTIST'S ADVICE
A homemade cardboard frame makes an excellent viewfinder that is very useful for helping you to choose suitable framings for your drawings.

▲ Selecting a small area of a subject brings a fresh dimension to what may otherwise be quite a boring drawing. Such framings can produce almost abstract compositions.

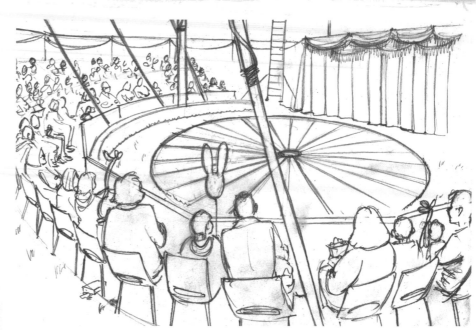

▶ If you broaden your field of view, new subjects become available to you. The central focal point of this sketch is essentially empty and all the interesting bits are around the edges.

◀ By looking down into a water butt I caught this unusual view of the reflections in the water. The view is focused on a small patch of space, concentrating the eye and eliminating peripheral detail.

◀ This panoramic drawing takes in nearly 360° of the scene in one flat image, more than the eye can normally see in a single view without turning the head from side to side. It required several days' work over three large sheets of paper. Note how the perspective has been distorted to accommodate the unnatural field of vision.

Making Arrangements

As an artist, you are under no obligation to draw things exactly as you find them; your task is not to document reality so much as to make interesting images. We have seen how your choice of viewpoint can influence your take on a subject, but you can push this a step further by enforcing your will upon the subject and altering how it is arranged for artistic effect.

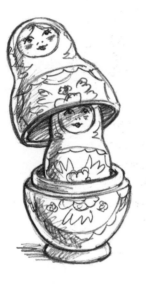

▲ This is a set of Russian dolls, just as I found them on the shelf. It is a pretty boring picture in every sense, but it need not have been. Even a subject as formless and unexpressive as this can be rearranged in almost limitless ways for the sake of impact, quirkiness or fun. You may need to give items extra assistance, such as propping them up, sticking them together with tape or manually holding them in position, but there is no need to show those practicalities in your drawings. Also, you can bring in extra elements or simply add them from memory. Remember: in art, anything goes.

◀ With a subject as richly articulated as the human body, the possibilities are greater still. In posing his model for this bust, the sculptor has brought great tension into the pose through the twist and tilt of the neck and shoulders. From any angle this pose would make for a dynamic sketch.

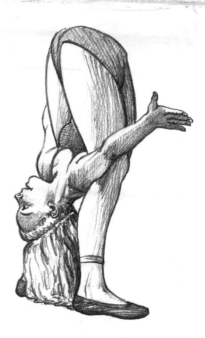

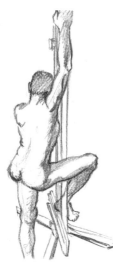

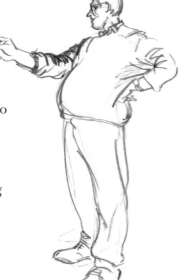

◀▶ Some of the best poses come about in collaboration with a life model. Asking them to follow simple actions or to interact with basic props will add an extra dimension to a pose and result in more interesting drawings.

▲ The human body is capable of bending into the most amazing shapes. Extreme contortions, like that of this street performer, are impossible to hold for any length of time, so it may be necessary to work from photographs.

ARTIST'S ADVICE
When arranging difficult poses, be prepared to work quickly to avoid inflicting discomfort on the model. Time pressure can benefit your work as the model's tension creeps into your drawing with often quite dynamic results.

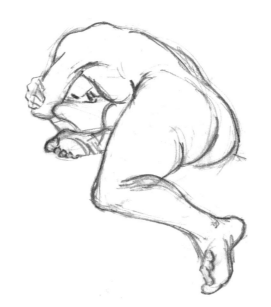

◀ It is equally valid to pose models merely for the shapes their bodies can make. Strong, flowing curves, sharp angles, physical tension and so on are all effective elements in a pose.

Drawing Language

Thus far we have concentrated on what to draw, selecting subjects and viewpoints from the world around us. The next thing to consider is how to treat the chosen subjects, which brings us to the slightly obscure realm of 'drawing language', or 'style'.

Every artist quickly develops a unique manner of drawing, just as everyone has recognizable handwriting. For example, most of the images in this book should be generally identifiable as being by my hand. Although it would be folly to try to change the way we draw once we have found our style, each new drawing still presents us with infinite possibilities. Our choices of materials, technique, scale and so on will very much affect the outcome. More important still is what we choose to convey.

When you pare down a subject to an essential function, you are likely to make a drawing statement that has impact. Always try to be clear and unswerving about what you aim to achieve with every drawing.

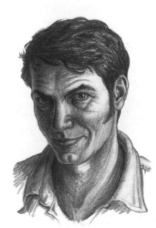

◄ Attempting to render a drawing with photographic objectivity will usually cause you a lot of hard work for little effect. Here I carefully recorded every modulation of light on every wrinkle, but it is a boring drawing, little more than an academic exercise.

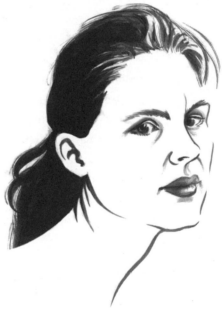

▲ Here is a simpler, more considered treatment. Ignoring most of the light and form on the woman's face and concentrating on her basic features achieves a fresh, elegant feel, instantly more eye-grabbing than the over-worked drawing above.

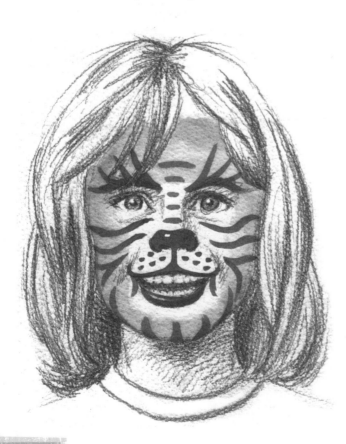

◄ This head is rendered in two different drawing languages. The basic portrait is sketched in loose pencil marks, but for the girl's tiger stripes I used a brush and watercolour. This mimics the way the make-up was applied and makes a clear distinction between the natural and the artificial.

▼ Here I have deliberately restricted the drawing language to bare, uniform pencil lines. The aim is to convey a sense of confusion in the jumble of lines and shapes. A more sophisticated treatment would clarify the divisions between the objects and spoil the effect.

SIMPLIFICATION
If there is one golden rule that can guide us towards making successful drawings, it is that old but true cliché 'less is more'. It cannot be stressed too strongly or too frequently. Good artwork is more about what you decide to leave out than what you include. Any fool can make things complicated; it takes a thoughtful artist to keep things simple.

Pencil Line

To start our investigation of simple drawing language, let us pare things down to basic line drawing. While an outline drawing may appear to be the easiest approach, it is not without its difficulties. With pure line, you do not have any extraneous marks to hide behind; every stroke of the pencil stands to be judged, not just for the form the line describes, but for the weight and quality of the line. However, there are ways to ease the strain.

▶ It takes great confidence to put down outlines in a quick sketch like this without prior underdrawing, but that is what makes such drawings effective. Every mark that you make could potentially spoil the drawing, so keep it as minimal as possible. Accept from the start that it may take many attempts before you achieve one success. A blunt pencil is very forgiving compared to the precision of a fine point.

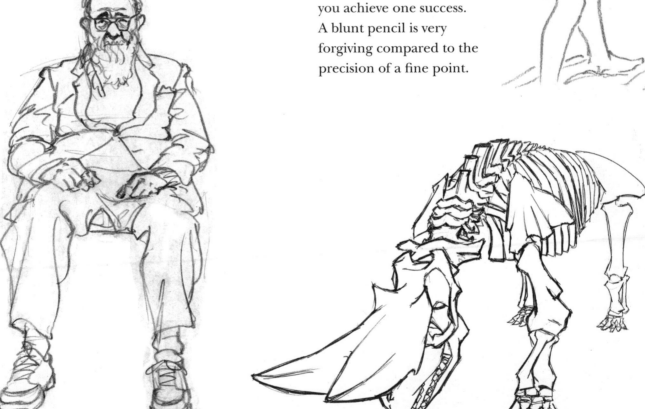

▲ By choosing a subject that is scruffy and unkempt you are not faced with the same pressure to keep the lines graceful and precise. However, it is still effective to make your marks fluid and confident.

▲ The fine point of a mechanical pencil, combined with angular, stabbing marks, lends this ancient skeleton an appropriately hard-edged feel. Note that the lines are heavier for the foreground bones and less distinct towards the back. This helps to create a sense of depth.

◄ It is often necessary to do a drawing twice over to get it right. Many great artists do rough versions before embarking on a masterpiece. Here I have made a carefully observed sketch, but as you can see it is riddled with guidelines and errant marks.

◄ However carefully I attempt to clean up the drawing, it remains quite rough and unrefined. The answer is to do it again, but this time with my first drawing as a guide.

ARTIST'S ADVICE
For the final drawing I used layout paper, which is thin enough to see through to a drawing placed underneath. To trace through onto normal drawing papers, artists work on a lightbox, effectively a translucent drawing surface with a lamp behind it. Alternatively, you could affix your papers to a windowpane and make use of the daylight coming through the window.

► By tracing the initial drawing onto clean paper, each mark can be made with complete confidence. For this final version, I used a very soft, broad pencil and thought carefully about the weight and breadth of each mark, making them darker in areas of shadow and fading out to nothing on the upper edges. The varied line helps to describe the subject's gentle contours.

Ink Line

In neat ink, all lines and marks are uniformly black. This dense black lends itself to bold graphic impact and, as it is stable when dry, any number of scruffy pencil guidelines can be erased with ease.

▶ Here is a rough sketch I made of a craftsman restoring an old wall. It is not very polished, but it will provide a good basis for an ink drawing.

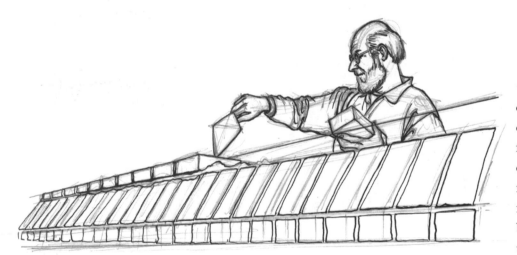

◀ With a flexible metal-nibbed pen, dipped into black ink, I carefully drew the outlines and developed the facial features – with experience of drawing comes the confidence to make up odd details without reference material. For the bricklayer's plumbline, I used a ruler to echo the precision of its purpose.

▶ When the ink was thoroughly dry I could erase all the pencil marks, leaving the clean ink line. Then I strengthened some of the outlines to give a sense of weight and solidity to the figure and bricks.

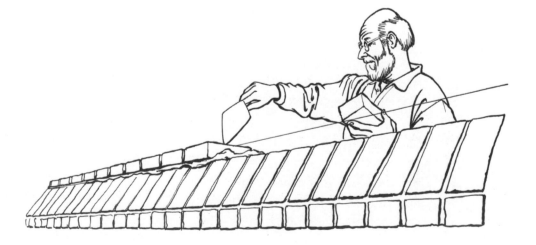

▶ Here I used brushpen – a felt-tip with a brush-shaped nib, which produces bold marks of varied breadth. I also shaded the very darkest areas of the clothing with solid black, which lends the figure a sense of solidity.

◀ I accidentally splattered ink on this drawing and dabbed the messy ink blobs with a tissue – but I was pleased with the resulting textural look of rough stone so I repeated the effect over the body, shaking the pen and dabbing with a tissue. Once it was dry, I used white ink to cover the marks that had strayed beyond the outlines.

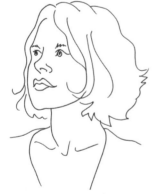

◀ The even line of an ordinary felt-tip pen lends itself to a stripped-down approach. Here there are no fancy techniques or effects to hide behind and it took me many failed attempts along the way. It is often advisable to work over light pencil guidelines.

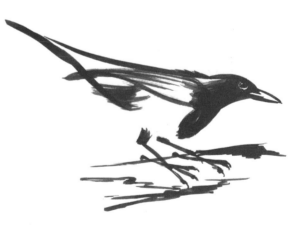

ARTIST'S ADVICE
Artists' dip pens take a little practice to get used to, especially in the way the nib responds to pressure to produce lines of varying thickness. Practise doodling on scrap paper to gain a feel for the tool. Always use downwards or sideways strokes to avoid the nib splattering. Be sure to rinse the nib in water when you have finished.

▲ There is a fresh and unfussy quality to this ink and brush sketch that can only be achieved by drawing very quickly and confidently. I worked from a photograph, using a Chinese calligraphy brush and cheap fountain-pen ink.

Ink and Texture

Still using nothing more than pure black and pure white, it is possible to bring greater sophistication to your designs by introducing texture. It is not difficult to convey texture in a black line drawing, but you must be careful that you make the appropriate kinds of marks for the surface you hope to describe.

▶ Here I used an artists' felt-tip drawing pen to establish the outlines over a fairly rough pencil drawing. I made the lines appropriately jagged or smooth where necessary. The texture of the outline is very important to the way a drawing reads when finished.

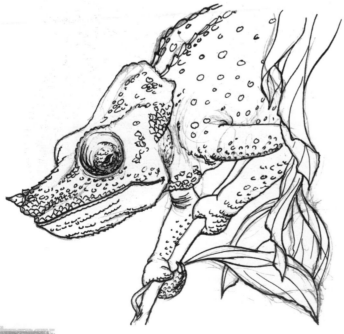

◀ With the same pen I then made some scaly marks over the body, observing the sizes of the scales, tiny around the eye, larger on the back. It is not necessary to draw every scale; a few well-placed examples suggest the overall surface. Here I concentrated on texturing the 'mid-tones', the areas where light and dark meet across the body's surface. I also marked some detail on the leaves, using unbroken curved lines in contrast to the lizard's texture.

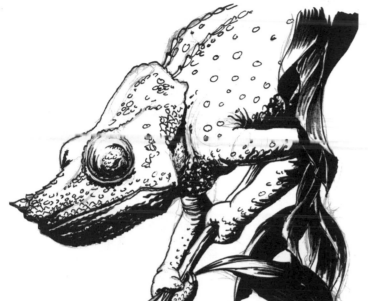

◄ Some drawing ink and a fine brush filled in the areas of deepest shadow. In reality, the light and shade on the chameleon was much more subtle than this, but simplifying the lighting has an exaggerating effect and makes a strong feature of the texture, which is what this picture is all about.

► After erasing all the pencil guidelines I added more scales here and there to blend the transitions from dark to light. I also made some outlining bolder and used white ink to correct errors and pick out some scales against the black. The texture in this picture has the effect of making the body seem rounded and three-dimensional, the scales working like shades of grey in between the black and the white areas.

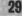

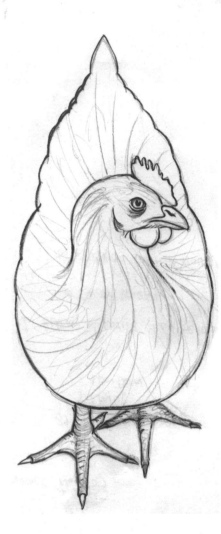

▲ This drawing is based on a photograph of a chicken taken from a steep angle. I liked the formal symmetry of the body and the framing of the head within it. I started with a simple underdrawing, where I was careful to note the direction of the feathers in the plumage. Then, using a fine watercolour brush (no. 3) and black drawing ink, I carefully outlined the main shape and the features of the head.

▲ With a larger brush, I filled in areas of solid black, using the appropriate textural marks in the transition from the paler chest to the very dark back.

▲ Switching to white drawing ink, I drew detail into the solid black area and added some highlights to give form to the feet. I also used the white ink to break up the outline around the breast to give the bird a more delicate, feathery feel.

Tone

Tone refers to the shades of grey between the extremes of pure white and pure black. It may take the form of delicate pencil shading, ink hatching, flat slabs of grey paint, smudged chalks or charcoal and so on. In a drawing, tone can perform many functions: it may describe light and shade, surface texture, three-dimensional form and local tone, and it may also serve the formal qualities of picture-making.

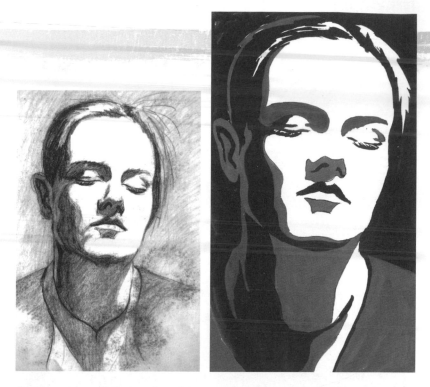

▲ The strong lighting for this pencil sketch naturally bleached out the brightest parts of the face to pure white. In the second version, I further reduced the shadow areas to broad masses of black and grey poster paint. Though crudely applied, the effect is immediately more striking.

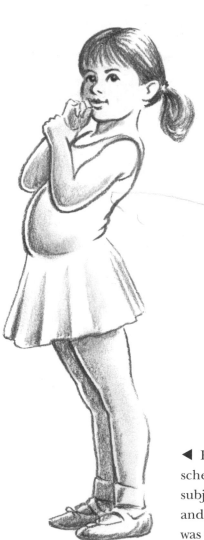

◄ The two shades of grey in this drawing depict only the 'local tones' – the inherent tonal values of an object. Without the effects of light and shade, images may be confusing to the eye, but careful design (like the mat here outlining the feet) can provide the necessary clues.

◄ For this charcoal drawing, I contrived a minimal shading scheme to bring out the softness and roundedness of the subject. It is not a realistic portrayal of the lighting conditions and, other than the hair, there is no local tone present. My aim was to avoid adding any unnecessary marks.

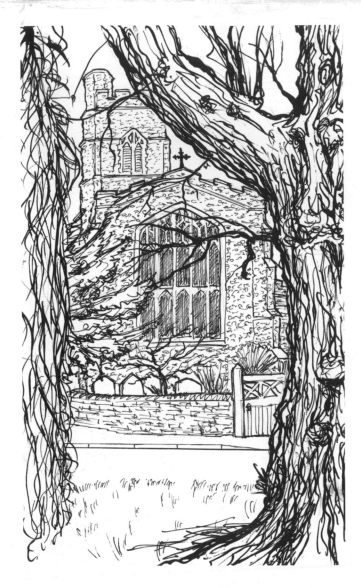 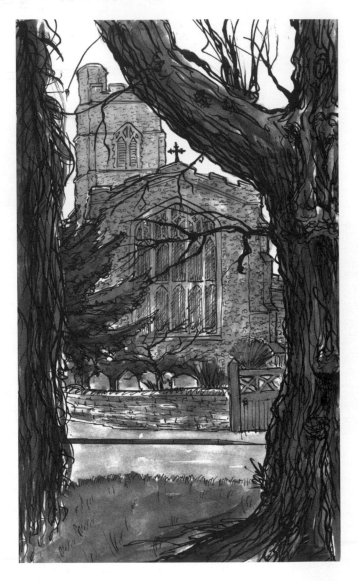

▲ Despite the use of a range of marks, the ink line drawing here struggles to be clearly readable.

▲ With the addition of some very rough washes of tone, the layers of depth in the scene are easily discernible.

ARTIST'S ADVICE
Applying washes of diluted ink or watercolour is a quick and easy way to introduce tone to your drawings. Use a soft, well-loaded brush and make sure that the drawing is done in pencil or ink that is not water-soluble. It is also important to work on paper that is heavy enough to resist buckling with moisture.

These three prints came from the same blocks, inked up for two, three and four tones. You can see what a difference the number of separate tones makes in the clarity of the scene, the level of detail and also in the mood or atmosphere of each finished print.

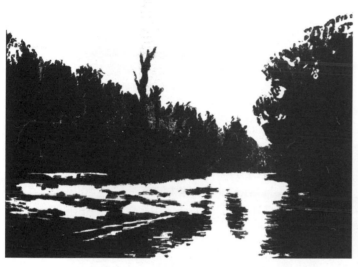

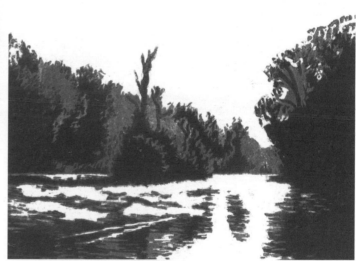

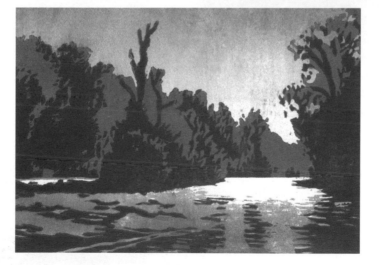

Toned Paper

A great way of getting used to drawing with simplified and controlled tones is to work on grey or coloured papers, known as 'toned grounds'. The benefit is that the mid-tone is already established, so all you need to worry about are the very dark and the very light areas. Bear in mind that a strong image will result from leaving a lot of the paper's tone untouched.

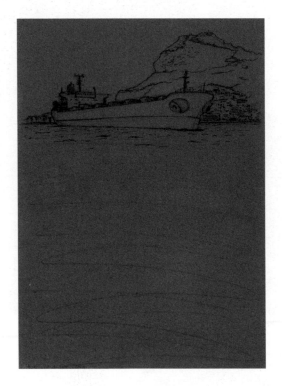

▲ This picture is based on a photograph I took from a small boat. The low viewpoint gave me an imposing view of the ship and distant land mass and also a close up view of the sea's surface, which suggested this framing of the scene. Very rough pencil guidelines established the basic shapes and set a scale for the ripples of the sea.

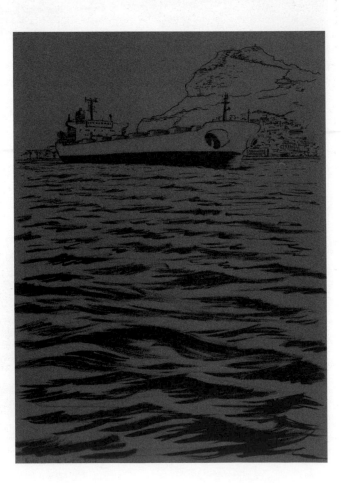

▲ A 5 mm artists' felt-tip pen (with permanent ink) was a good tool with which to add some detail to the background. The fine line and sparse detailing keeps the objects looking distant.

► Using a medium-sized round watercolour brush, I filled in the solid black of the ship and worked on the sea. Rather than trying to slavishly copy the actual waves from my source photograph, I simply aimed to capture something of the characteristic texture of gently rolling water. The important thing is to make the marks bigger and bolder in the foreground and diminish evenly towards the horizon.

▶ With the tone of the sea established, the background was looking weak, so I used the pen to add more tone and texture.

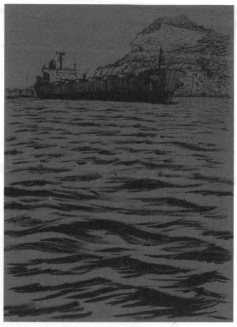

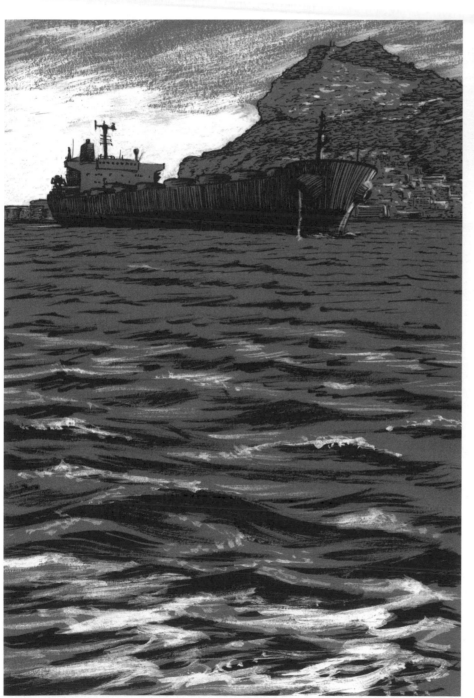

◀ Here you can see the great benefit of toned grounds; with just a few accents in white ink, the whole picture springs to life and the highlights really stand out strongly. It is easy to get carried away at this stage, so remember to let the grey of the paper remain wherever possible.

Tone and Texture

The further you delve into the world of tonal drawing, the more important are the marks you make to describe different textures and surfaces. Even tools as basic as pencil and charcoal are capable of a great range of textural expression, which you should exploit to bring clarity and feeling to your work.

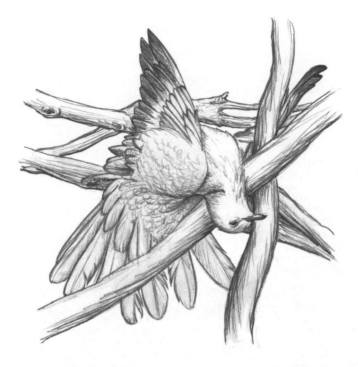

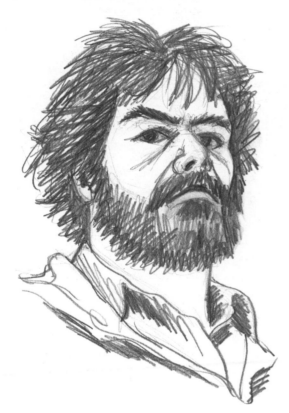

▲ Though the picture is quite gruesome, this is still a beautiful creature and I strove to capture that in smooth, unbroken strokes of the pencil. Different areas of plumage required different kinds of pencil marks, as did the harder surfaces of the entangling vines.

▲ I sketched this quick self-portrait during a spell of ill-advised beardedness. The vigorous textural marks make up most of the drawing here, with just a little outline detail to give context to the textural shapes.

▶ For an interesting take on these old shoes, I strung them up on an old wooden door. I went for a deliberately loose treatment and allowed the point of the charcoal to roam around the outlines and wrinkles of the leather. A few vertical strokes are sufficient to suggest the grain of the door, in contrast to the busier marks of the shoes. I kept the chalk highlighting to a minimum, so as to avoid anything looking too shiny and new.

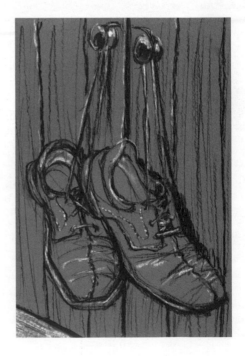

▶ Here I used a short stump of charcoal laid on its side to make some very simple, broad strokes of tone. I then added selective spots of detail with a black brush pen. I was careful to keep the detail minimal and allow the initial freeform charcoal marks to do most of the work.

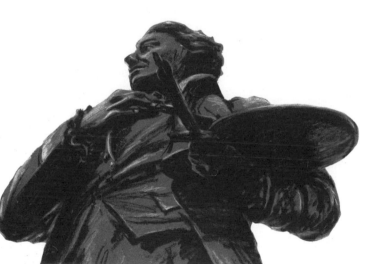

◀ To sketch this bronze statue I took no particular care over the marks I made, being more concerned initially with drawing the form and capturing the light and shade. I worked on grey paper with chalk and charcoal, filling in the background afterwards in white ink.

▶ Because chalk and charcoal are so unstable it is possible to blend the tones of a drawing with the tip of a finger. Here I kept all my smudging strokes in a uniform diagonal direction. Where I restated some details in charcoal or chalk, I made all new marks in the same direction.

Experimenting with Texture

Every different tool and material has its particular strengths and individual characteristics. As you become accustomed to using them, you will quickly gain an instinct for which methods are most appropriate for particular effects. Mixing materials and techniques can produce very effective, individual and often unexpected outcomes.

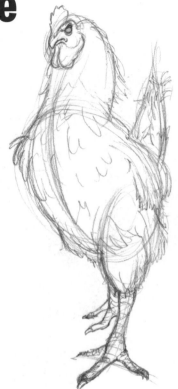

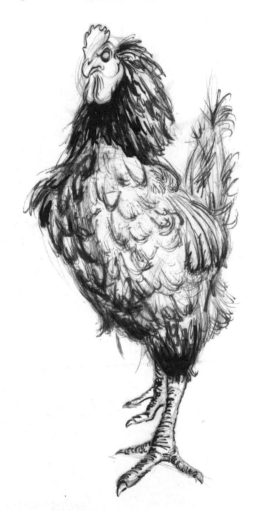

▲ This hen-pecked ex-battery chicken was one of the ugliest creatures I have ever seen. I wanted to capture its extreme scruffiness, as well as the attitude it displayed strutting around my aunt's farmyard. To get into the right frame of mind, I chose to work on the cheapest, flimsiest paper I could find. I then scribbled the main masses and just enough bare detail to guide me for the ink at the next stage.

▲ With a fine brush and neat black writing ink, I outlined the main details of the head and feet. This would provide the drawing with some recognizable elements which would allow me to be less restrained with the rest of the body. For the ruffled feathers, I switched to a very old and battered watercolour brush that splayed out to form several points. This automatically provided the appropriate feel for the feathers.

> **ARTIST'S ADVICE**
> Don't throw away your old worn-out brushes; they can be used for all sorts of painting and drawing effects that would otherwise be difficult to achieve.

◄ Artists normally try to avoid getting dirty fingerprints on their artwork, but here I dabbed on neat ink directly with my fingertips, aiming for a sense of carelessness. I then diluted the ink and used a coarse bristle brush to wash it across most of the hen's body. Then, for extra scruffy effect, I dipped an old toothbrush in the ink bottle and splattered the drawing with dust-like speckles.

► Once the ink and wash was dry, I applied more fingerprints, this time in white drawing ink, which brought out the roundedness of the body as well as providing the textural feel I was after. Using the same ink with a brush, I added a few accents and highlights here and there to reassert the drawing and vary the texture of the different kinds of feathers.

Illumination

Much of the past few pages has involved a sense of light and shade; we can hardly think about tone without it. However, there is more to be gained when we concentrate on illumination as an essential part of a drawing. Lighting is one of the artist's most powerful tools for conveying atmosphere, drama and dynamic impact, just as it is in the medium of cinema.

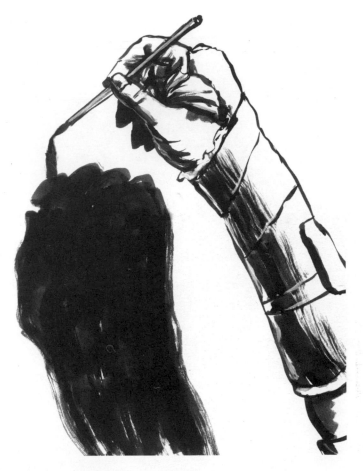

▶ Here is a rough sketch I did after a wrist operation. It is crudely drawn, but the lighting gives it some impact. In this image we see the two main effects of bright lighting: the shade along the inside of the arm and hand, and the shadow cast on the surface below.

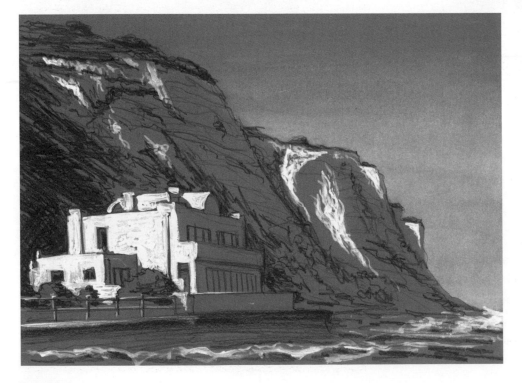

◀ The bright side-lighting here makes the building stand out sharply against the background, but light does more than aid our reading of this scene; it forms an important compositional focus without which the picture's impact would be greatly diminished.

▶ The depth and quality of shade immediately implies the strength of light, however simple the image. For this swift study I used a few deft strokes of diluted ink to state the shading. The same grey tone gives the outlining of the back a brighter feel compared to the pure black ink of the darker detailing.

ARTIST'S ADVICE
If you find yourself overwhelmed by the subtleties of tone in a subject, try squinting your eyes as you analyze them. This simplifies a scene into broad masses of tone.

▲ Lighting need not be dramatic to be effective. Here I intentionally subdued the lighting by reducing any tonal contrasts to shades of grey. The result is a bleak atmosphere that would be less effective with bright highlights and deep shadows.

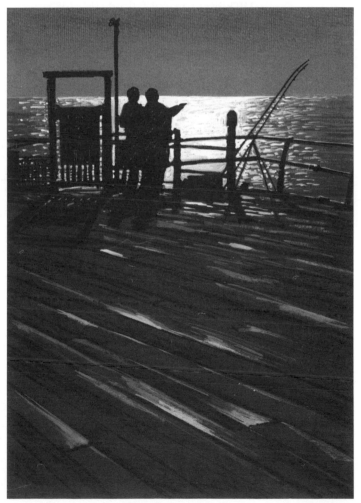

▶ Looking into the direction of light rewards us with bright reflections and silhouetted details, resulting in an immediate sense of drama.

Drawing with Light

We have seen how adding bright highlights to a drawing can give it an instant lift and breath of life. We can also make drawings that are composed almost entirely of highlights. Working on a black surface with a white drawing tool produces an effect known as *chiaroscuro* and makes for dramatic images. It takes a little thought, though, because drawing with light is the very reverse of the conventional drawing process.

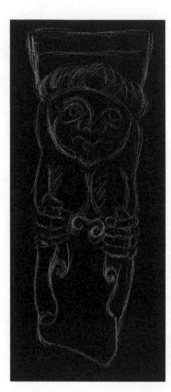

► Scraperboard is composed of a chalky layer covered with a dense black surface. A scraping tool cuts through the top layer to reveal the pure white beneath. This medium is ideal for drawings of great tonal contrast and also lends itself to very finely detailed work. Working from a photograph of a characterful medieval wood carving, I drew the rough outlines onto the scraperboard using a soft white pencil.

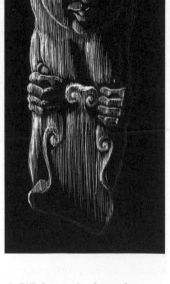

▲ With vertical strokes, following the grain of the weathered wood, I scratched away the outlines and broad masses of light on the illuminated left-hand side of the image.

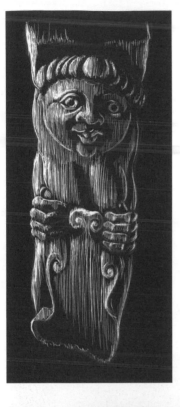

◄ I then inscribed the fainter secondary light on the right-hand side. However bright and direct the light source, there is nearly always a degree of reflected light which bounces off surrounding surfaces and affects the subject.

► Turning my attention back to the main lighting, I reworked the areas of brightest highlight to model the roundedness of the surfaces. For areas of extra brightness, I slightly varied the direction of scraping. A few spots of black ink corrected a few minor errors and I wiped away the remaining pencil guidelines with a damp cloth.

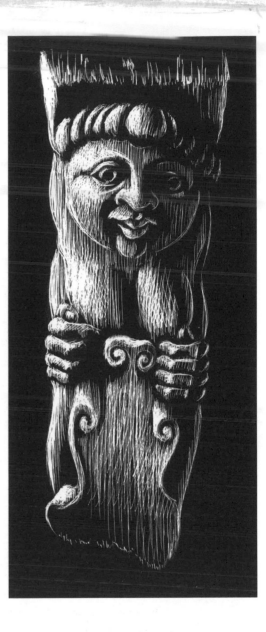

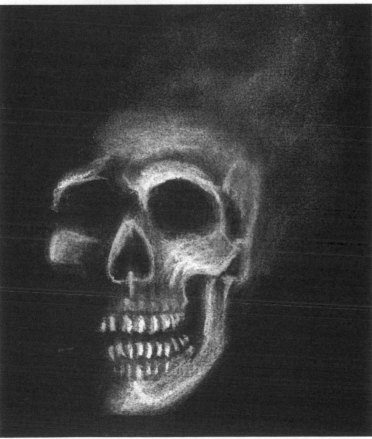

◄ For this chalk drawing I set up a skull on a dark background and illuminated it with a single candle, placed at a low angle to create an eerie effect.

I started by blocking in the masses of light with a stub of white chalk turned on its side. After smudging and blending the chalk with a finger, I used the end of the chalk to gradually refine the shapes and bring out the brighter highlights. I then corrected some stray marks with a soft eraser.

Drawing with an Eraser

Of course, erasers are essential for correcting errors, erasing guidelines and cleaning up spots and smudges. However, when the contrast of light and shade is a feature of a drawing, the eraser takes on another important use in picking out highlights and adjusting tones.

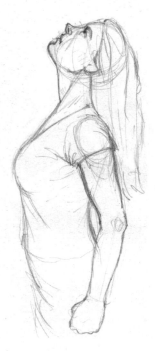

◄ I posed the model outdoors and had her look directly into the diffused daylight overhead. It was a hard pose to maintain, so I very quickly sketched the basic shapes with a fairly soft pencil and then took a photograph to continue working from.

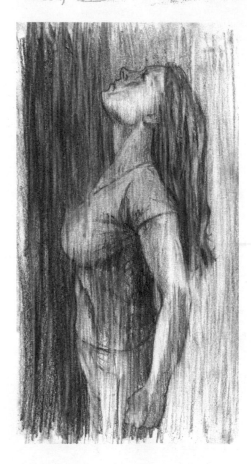

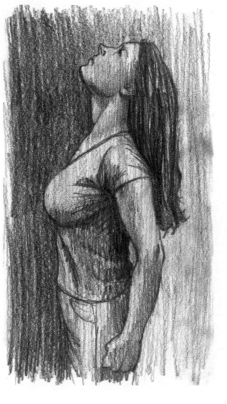

► With a soft pencil, (4B) I roughly shaded the main areas of tone. For the effect I had in mind for this picture, I did most of the shading in a strictly vertical direction and covered the whole surface with graphite.

▲ I used a hard plastic eraser to crudely lift out the main areas of light, again working in a vertical direction and allowing the eraser to smudge and pull the tone around.

► I sharpened the corner of a soft rubber eraser with a knife and used it to carefully lift out some more delicate highlights and generally draw the form back into the areas of light. I wiped the eraser clean after each stroke to keep the highlights clean and bright.

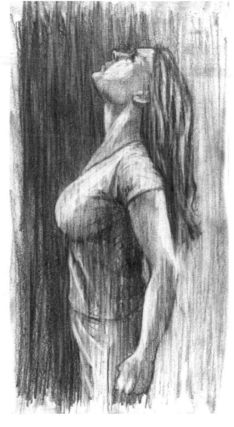

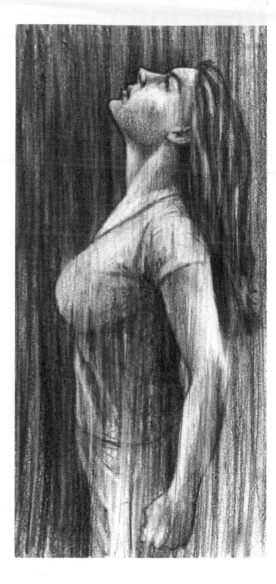

▲ For this final stage, I used a pencil style of eraser, sharpened to a fine point, to hone the delicate highlighting around the head. Then I reverted to the pencil to redraft details of the face and hair. I also used pencil and eraser to subtly adjust tones and textures all over the drawing.

ARTIST'S ADVICE
Heavily applied graphite can very easily be smudged with the heel of your hand. To avoid this, lay a clean piece of paper between your hand and your drawing. It is also good practice to wash your hands regularly.

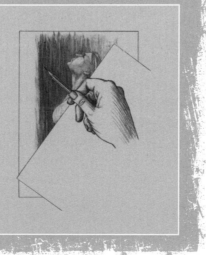

Composition

Throughout this book the artworks have tended increasingly to have definite edges, or 'framing'. This is a natural result of incorporating tone into the work, but it is also a very important subject in itself. Before progressing any further we should start to think of framing and the placement of the elements within it as an essential consideration for any drawing.

Composition is all about the balance and dynamics within a picture. It is a vast and fascinating subject. It will crop up repeatedly throughout the book, but for now a few examples will serve as a good introduction.

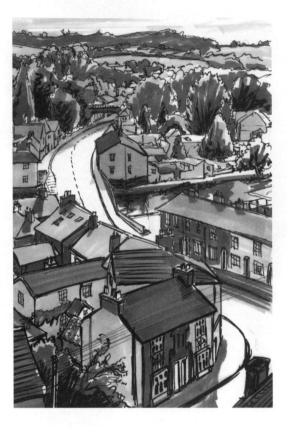

▶ CURVES
Running through this complicated scene is a bold and simple curve that leads the eye into the picture. Such a compositional device should be the first thing you draw; if the curve looks balanced and graceful, the picture will be all the stronger for it.

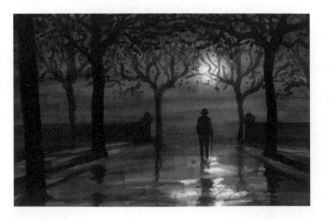

◀ THE GOLDEN SECTION
Since ancient times, artists and architects have followed a mathematical 'golden' ratio that dictates the most pleasing division of a space – about six tenths. So the horizontal division in this composition comes six tenths down the picture and the focal point (the figure) is placed at six tenths along that line. The golden section is a great shortcut to instantly gratifying compositions.

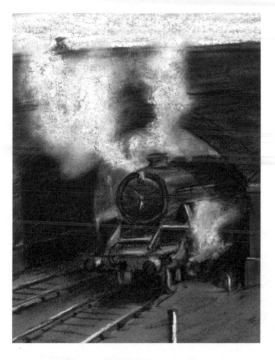

◀ A FRAME WITHIN A FRAME

Many compositions are based around bold geometric shapes. They are often not immediately visible, but they may also be very much a feature of a picture. One such device presents a subject through or within a frame-like structure within the picture. The effect may draw the eye into the picture and may echo the staging within a theatre's proscenium arch; it may also feel voyeuristic.

> **ARTIST'S ADVICE**
> Make quick compositional sketches before you start a drawing, since they will give you an immediate impression of how successful a composition may turn out to be. Looking at them upside down or in a mirror can reveal imbalances that may not be otherwise apparent.

▶ DIAGONALS

Here we see a level horizon at a pleasing six-tenths placement and further horizontal striations across the picture. But there is also a strong diagonal thrust in the two anchors, echoed in the tonal masses of the clouds.

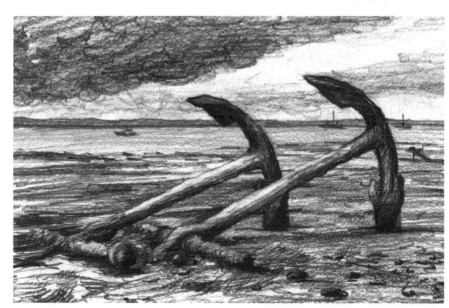

Distilled Composition

The further you develop your picture-making, the more you will come to appreciate the value of composition. To many artists, composition is the main ingredient of their work and all else is subservient to it. The following demonstration shows how a scene from real life can inspire a drawing of pure compositional form.

▲ This is a somewhat neglected city canal. It is not a scene of great beauty, but there was something in the curves and tree forms that caught my eye.

▲ Working from my photograph, I set about redesigning the scene as an ideal composition. I thought about the landscape features as abstract shapes and drew them as a set of pleasing curves on scrap paper.

ARTIST'S ADVICE
To convey a sense of depth in a picture it is necessary to mimic the effects of aerial perspective, which weakens tonal contrasts over distance as a result of atmospheric haze. Essentially, this means rendering distant features with less shade and weaker highlights, and increasing the contrasts between lights and darks as objects get closer to the foreground.

► With a soft pencil, I roughly shaded the shapes to arrive at a set of tones that had a satisfying balance across the picture yet also gave the landscape features depth and solidity. It is important to keep a consistent lighting direction throughout, which in this case comes from the right-hand side.

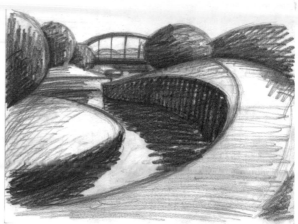

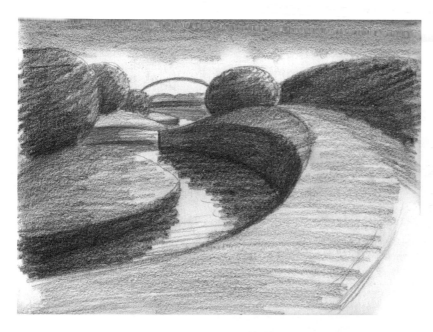

◄ Once I was happy with my tonal composition I took some fresh paper and redrew the scene. I used the side of a soft pencil to shade the basic areas of flat tone.

► With the basic tones established, I kept working over the whole picture, building up and adjusting the tones. I kept the texture very minimal, just enough to suggest a sense of difference in the surfaces. The result is a manicured, almost alien-looking landscape, worlds away from the scene that inspired it.

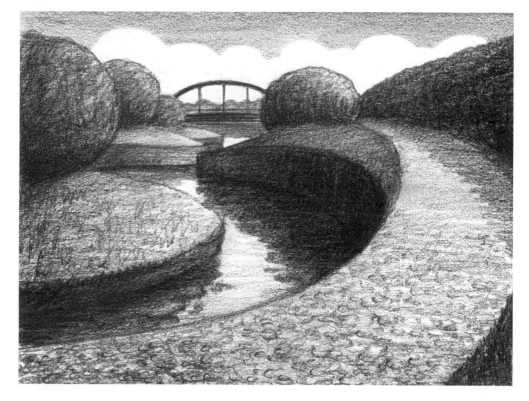

Combined Composition

Artists are free to interpret a scene or subject in any way that they please. Even when drawing a scene that exists in real life, it is common practice to omit certain details, move features around or adjust the relative scales within the picture. Whatever makes for a satisfying drawing is valid, just so long as you can make the alterations convincingly.

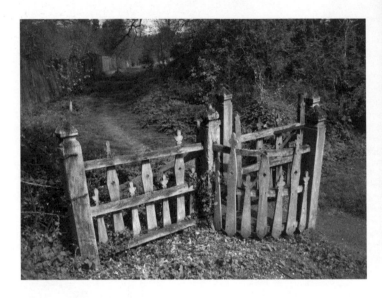

I stumbled across the scene on the right while on holiday and photographed it, thinking that the gently rolling landscape could make a useful background for an illustration. The kissing gate in the foreground put me in mind of a more picturesque version at a local church (above), which I later photographed to combine with my earlier scene.

▶ With a hard pencil, I drew the old gate, correcting the slightly distorted perspective of the photograph by straightening the posts to an upright position. For the background, I sketched the main shapes of the landscape features, exaggerating the curves of the hills and tree lines for aesthetic effect.

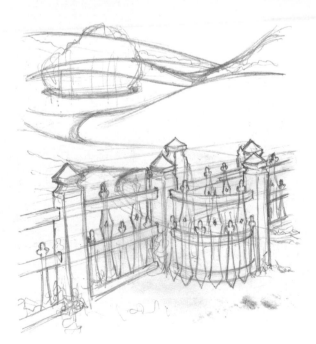

► With a dip pen and black drawing ink, I established the outlines of the gate and some rough shading, copying the lighting conditions of my source photograph. I also started working on some ground-covering foliage.

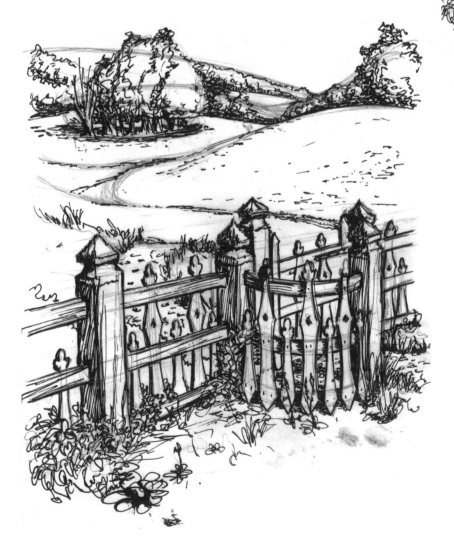

◄ With the foreground well established, I started work on the background. I loosely followed the tree forms of the photograph and made sure that I conveyed the same bright lighting and deep shadows of the foreground.

►

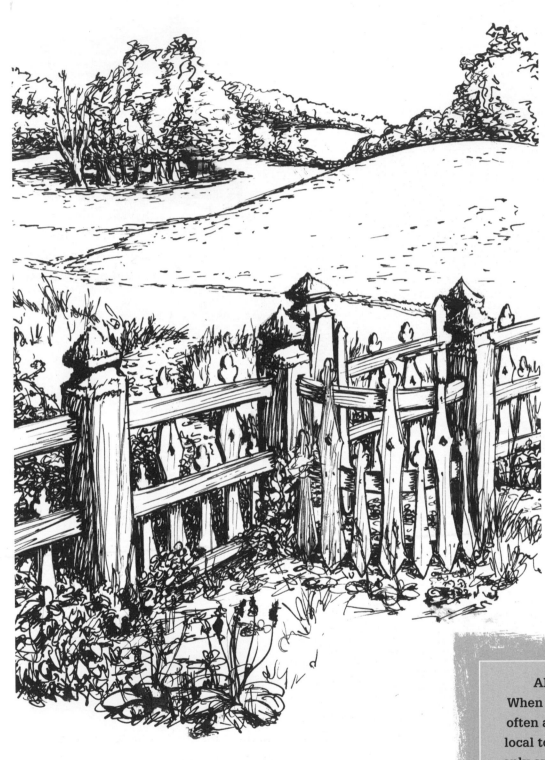

◄ After erasing all my pencil guidelines, I further refined the details in all areas of the picture. Crucially, I made the outlines of the foreground distinctly heavier than those of the distant features to create a sense of aerial perspective. I also added more plant life at the bottom to lift the composition and provide some breathing space at the bottom of the frame.

ARTIST'S ADVICE
When drawing in line, it is often a good idea to ignore local tones and concentrate only on the lights and darks created by lighting and texture for a bold, unfussy finish.

Condensed Composition

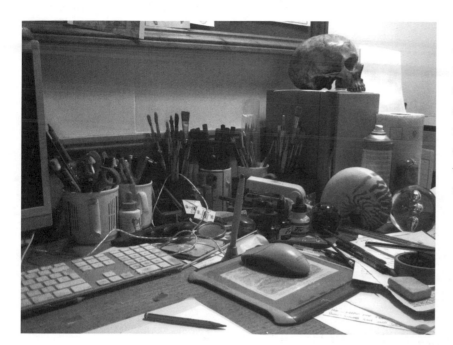

◀ With an imaginative approach to drawing, you can often find inspiration in even the most boring and familiar surroundings. When pondering a suitable subject for this demonstration, I needed to look no further than my own desk. Ashamed though I am of my untidy working practices, I thought I could turn this jumble into an interesting picture.

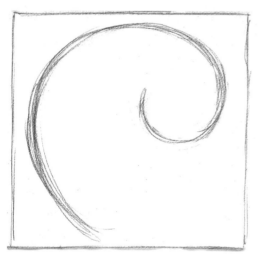

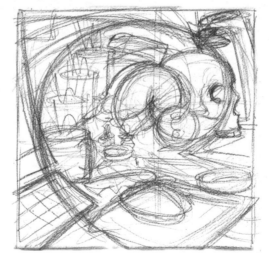

▲ Taking my cue from the seashell, I opted to base my drawing around a spiral – a common compositional device. I decided on a square format and drew the rough shape on some heavyweight watercolour paper.

▲ Without physically moving anything, I selected some elements of the scene so that they fitted within the forced compositional shape, just blocking them in roughly. For a really claustrophobic feel, I squeezed everything very close together, right up to the edges of the picture, and also allowed some lines to curve to follow the spiral. ▶

▶ In working up the detail, a number of changes presented themselves. I always try to keep a drawing quite fluid and open to changes all through the pencil stage.

▼ Once I was content with the drawing I used brush and ink to set the outlines in place, adding lots of detail in ink without prior pencil work. Such direct inking helps to keep the picture fresh and stops it from looking overworked.

ARTIST'S ADVICE
It can be very useful to look at your pictures in a mirror at various stages. The unfamiliar view can reveal mistakes and imbalances that you would otherwise miss.

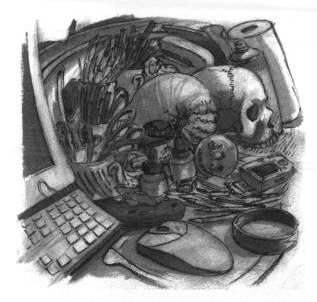

◄ After erasing the pencil marks, I mixed up some black watercolour into a thin wash and used a broad brush to roughly block in the areas of tone. For deeper tones I went over again with heavier washes, always aiming to keep the brushwork quite loose.

► In the finishing stages, I barely looked at the subject. Instead, I let the picture dictate what it needed for a good tonal balance and a sense of depth and solidity to the objects. With more black ink and watercolour I deepened the tones wherever necessary. Finally, I added some highlights in white ink with a fine brush.

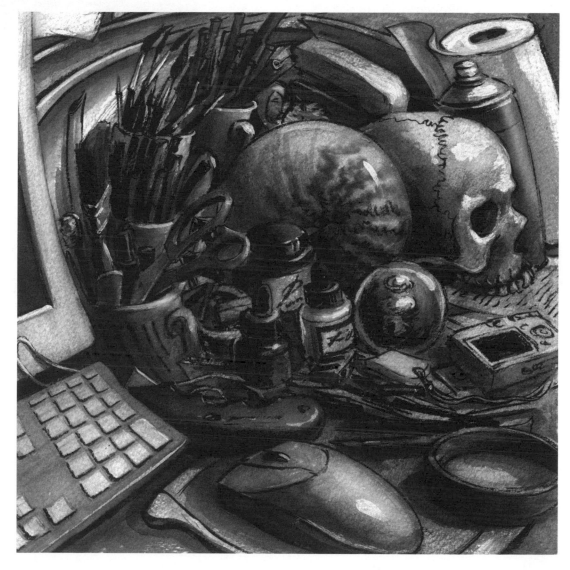

Collated Composition

Another approach to picture-making allows the composition to grow as more and more features are added. A family outing to a farm park inspired me to assemble the following picture from various views of a recurring motif.

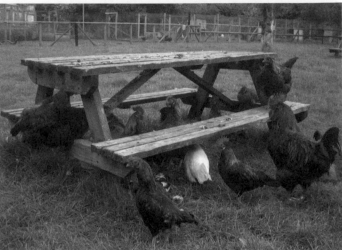

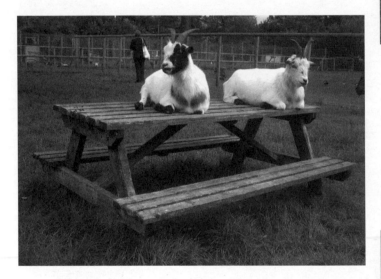

Having spotted goats on one picnic bench and chickens gathered around another, I pressed my family into posing on a third and photographed each from roughly the same angle and distance.

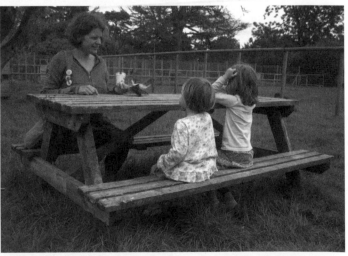

◄ Back in my studio, I copied the bench in the middle of the paper, allowing plenty of space for surrounding details. I drew all the structural lines in full to ensure a sturdy construction.

► After erasing unwanted guidelines, I drew the people seated in position.

◄ Referring to my other photographs, I placed the goats on the table and some of the chickens around the figures, deciding where they fitted best.

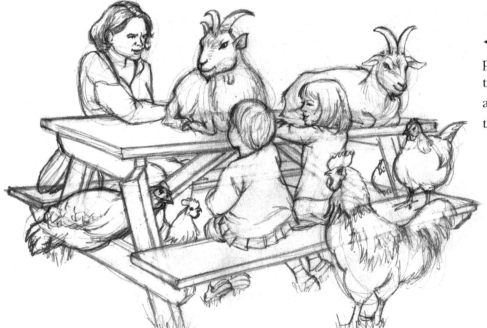

► By now I was having too much fun to stop, so I found pictures of other farmyard animals and crowded them around the scene. The cockerel in the foreground now looked too large, so I redrew him.

◄ To complete the scene, I drew the family's picnic and completed the detail of the bench. I also made up some background details to provide a suitable setting.

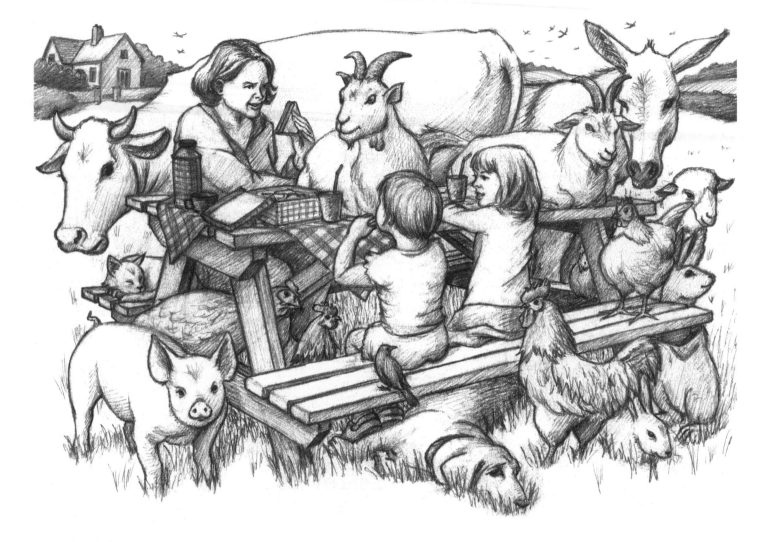

▲ Cleaning up and rendering this drawing took several hours of careful work with a fine mechanical pencil and the sharpened edge of an eraser. I was conscious of how easily the picture could become muddy and unclear, so I kept the shading to a minimum, only picking out a broad sense of shadow and avoiding much local tone. I added a sheep on the far right to fill a gap in the composition.

ARTIST'S ADVICE
When adding extra elements to a picture, bear in mind the three-dimensional space that each new thing needs to occupy. If you try to visualize where the feet of either human figures or animals would meet the ground it will help you to place them convincingly and keep the scale of added elements consistent.

Creative Composition

A scene from real life may be thought of as a mere starting point and changed in any way you can imagine. In this demonstration, I redesigned every element and changed not only the light source, but also the time of day.

▶ I thought this holiday snap contained all the elements of an interesting picture, but the composition is weak and the lighting is very flat.

▲ Having decided on a night-time scene, I used grey paper and sketched the main features in charcoal, starting with the scarecrow, which I wanted much larger in the frame. The other elements fitted in around him, changing in proportion or placement as I saw fit.

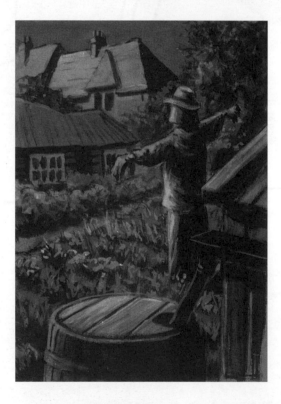

▲ I roughed in the main areas of shadow with charcoal, aiming for a tonally balanced composition that would be clearly readable. I then added washes of diluted black watercolour and white ink to build up the mid tones and the lighter mid tones, bringing some depth to the picture.

ARTIST'S ADVICE
Night-time
pictures usually
work particularly
well where there
is backlighting.
This allows for
plenty of deep
shade and crisp,
bright 'halo'
highlights that
are atmospheric
and also easy
to visualize.

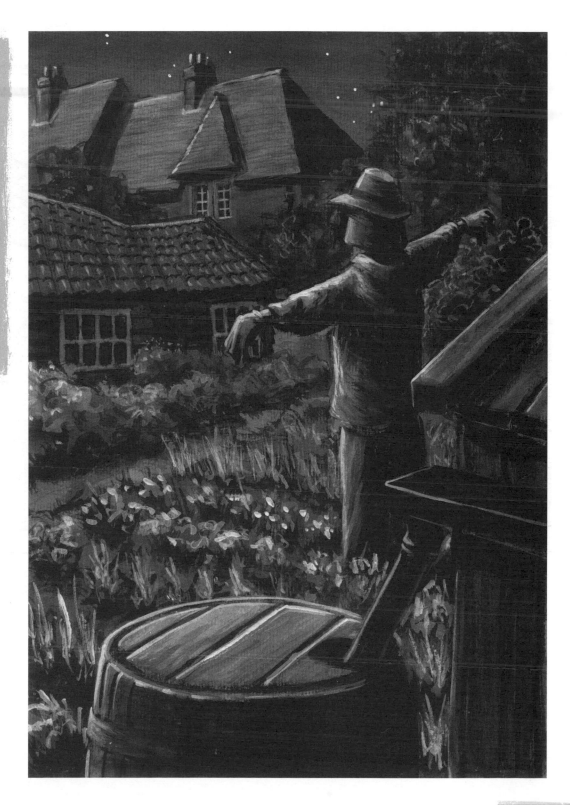

▶ Using any tool that felt
appropriate – felt-tip,
pencil, white pencil and
more brush and ink – I
sharpened up the
drawing and added
details here and there.
A fine brush and neatly
applied white ink lifted
out some bright
highlights, which gave
the effect of moonlight.

Framing

As you have learnt, the arrangement of elements within the frame is one of the most important factors in the success of a finished picture. However, compositional options do not end with the completion of a picture; altering the size, shape and placement of the framing can bring an extra dimension to a work. You can also plan your pictures to work within a particular framing device from the start.

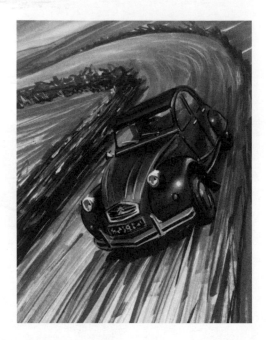

▲ TILTING

Altering the angle of a picture within its frame presents an unsettling image and suggests dynamic movement. Skewing this rather ordinary car picture seems to radically enhance the feeling of speed by making the road appear very much steeper.

▲ EXTREME CLOSE-UP

Closing in on a particular detail can have a concentrating effect, cutting straight to the heart of a subject. Sometimes a weak piece of artwork can be brought back to life by framing off the less successful parts to make a new, tighter composition.

▲ ABSTRACTING

Another way to salvage a failed picture is to frame it off as an abstract composition. I was never happy with this image as a portrait, but I liked the loose poster-paint brushwork. Excluding most of the recognizable features allows the viewer to focus on the tones, shapes and mark-making rather than the subject.

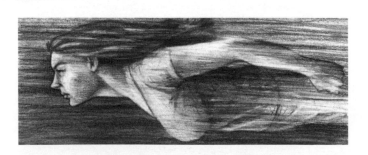

▲ ROTATION

A very different feel can result from turning your pictures around for presentation. This vertical figure from page 45, when turned on its side, suddenly looks rather like a superhero flying at speed.

▼ ▶ EXTREME FORMATS

Some subjects naturally demand more than the standard short rectangle picture area. The panoramic 'letterbox' format gives an instantly cinematic feel to quite mundane subjects. Similarly eye-catching, very tall formats exclude peripheral details from tall subjects and strengthen the sense of vertical distance.

ARTIST'S ADVICE
Two large L-shaped pieces of cardboard laid on top of your artwork will help you to work out all the potential framing options before you make a final decision. There is no need to cut off the unwanted parts to present a new framing; instead, take measurements from your L-shapes and cut out a paper or cardboard frame to affix over the artwork.

Emphasis

Whether you are drawing large, expansive scenes or modest individual subjects, there will be certain elements of your pictures to which you want to draw particular attention. There are many sophisticated ways to do this and we will explore them later in the book, but for now let us look at some simple devices for emphasizing the features of your pictures that you wish to be noticed.

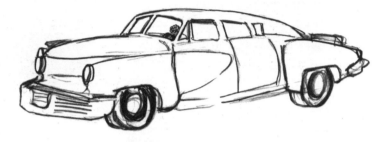

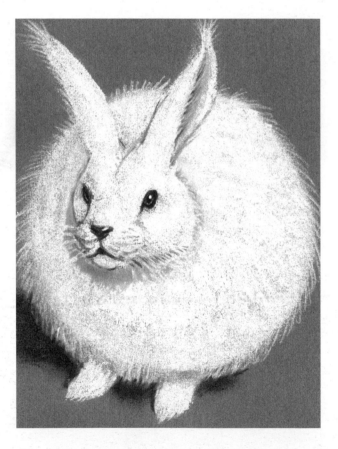

▲ When drawing this old car I was struck by its sheer size, compared with modern cars. As a little joke for myself I sketched in an old lady behind the wheel, giving the car an immediate sense of scale, emphasized by her exaggeratedly tiny stature.

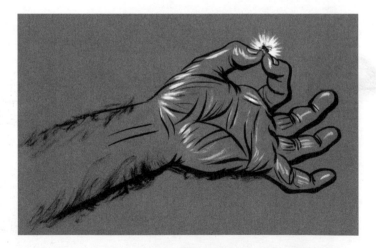

▲ To emphasize the texture of this rabbit, I ignored any anatomical detail and drew it as a simple ball of fluff. By making the head relatively lifelike (and not overly cute), the drawing reads as a fairly accurate representation. A tight cropping lends the creature a sense of bulkiness as it fills the frame.

▲ I wanted to make a feature of the fly's smallness. Placing the subject against another familiar object, the hand, we get an immediate feel for its size and relative vulnerability. And just in case the fly should go unnoticed, I used a 'starburst' effect to pick it out against the background.

◀ For this demonstration, I worked from a photograph of my wife taken on a memorably wintry day. I first drew broad shapes with the edge of a charcoal stump to establish the physical thrust of the figure. It was then quick and easy to draw more detailed line work with the charcoal's point.

▼ Here I added a few simple effects to emphasize the figure's exertion. Some blades of grass and a few strokes of flowing hair suggest the buffeting of the wind. With the corner of an eraser I lifted off the charcoal in diagonal strokes to form streaks of driving snow. To finish, I skewed the picture to give the impression of an uphill slope.

ARTIST'S ADVICE
It is advisable to err towards subtlety when adding effects to your drawing; it is all too easy to overdo things and end up in cartoon territory.

Exaggeration

There is often a fine line between the concepts of emphasis and exaggeration. For our purposes, we shall regard exaggeration as the wilful manipulation of proportions intended to bring out a heightened sense of character in a subject. This is one of the most potent devices in an artist's bag of tricks for imposing an artistic vision or comment on a subject.

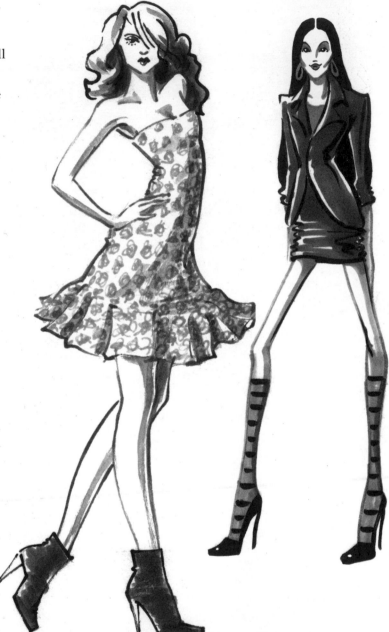

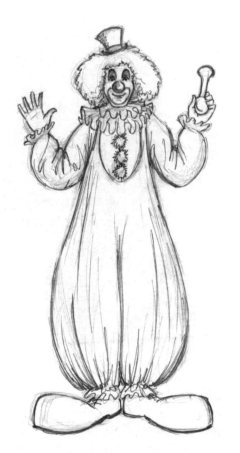

▲ In the design of a clown's costume, nearly every part of the body is distorted in some way. The feet are comically huge and the bulky wig is emphasized by a tiny hat. Facial features too are exaggerated with make-up. Baggy or padded clothing hides the natural form of the body underneath. In drawing such a character you are, of course, free to further exaggerate any elements you wish.

▲ Designers and illustrators in the world of fashion routinely elongate the stature of the female form to comply with a certain ideal of beauty and grace and show off the clothing to its best advantage. Posture and contour are also exaggerated far beyond what is natural for even the tallest and most limber fashion models.

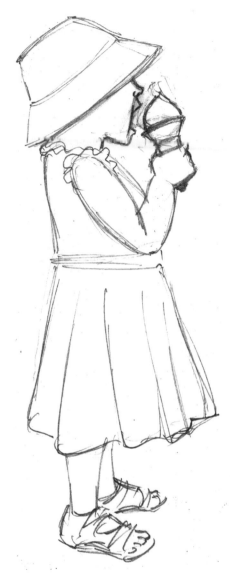

▲ Exaggerating form need not be so blatant as the previous examples and often works more effectively when applied with subtlety. To demonstrate, here is a sketch I made while my small daughter was engrossed in eating an ice cream. Supplying children (and animals) with food is a good way of keeping them still for the duration of a quick sketch!

▲ Back in my studio, I placed some thin layout paper over the original sketch and traced the original. In doing so, I enlarged the hat, ice cream and mouth, reshaped the belly and skirts and exaggerated the arch of the back. I also reduced the size of the hand to emphasize the large ice cream. None of these changes is very dramatic, but they add up to a more charming and characterful image.

▲ To convey the details convincingly, before rendering the drawing I referred again to my daughter's outfit. I decided upon a lighting direction and made the shadows quite deep to convey the brightness of warm sunshine.

The concept of exaggeration can be applied to many different aspects of drawing, depending on the subject matter and your intended take on it. The following examples show just a few of the ways in which subjects can be manipulated for effect.

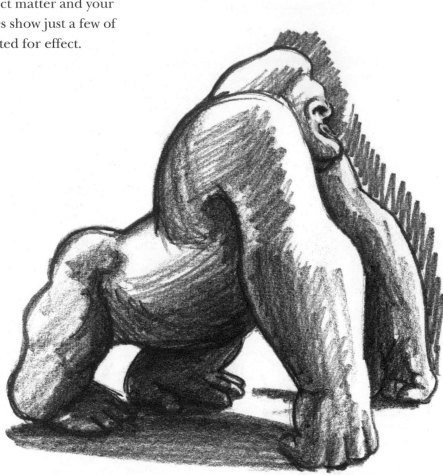

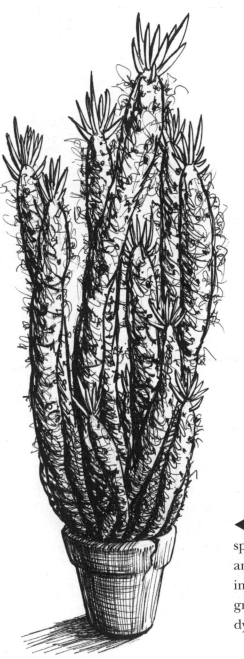

▲ This sketch of a bronze statue shows how the sculptor has exaggerated the gorilla's proportions to convey muscularity and solidity in the greatly oversized arms and the sharply delineated contours of the back and buttocks.

◄ To capture the vigour of this cactus, I exaggerated its spiky, hairy and engorged textural qualities with varied and energetic pen marks. The contrast with the pot is important here: it is plain and methodically shaded, and greatly reduced in scale to emphasize the plant's dynamic growth.

► In sketching this sleeping bloodhound, I stretched the muzzle and ears widthways to emphasize the baggy skin and wrinkles.

▼ It is the angles that are exaggerated here to convey the olde-worlde charm of this medieval inn with its bowed and twisted timbers.

Distortions

The distorting effects of mirrors and lenses can be employed to bring a sense of quirkiness and intrigue to your subjects. The following drawings depict some of the more extreme effects you can use, but you may prefer to experiment with more subtle applications.

▲ I drew this bizarre portrait from a photograph taken with a fish-eye lens. It has the effect of grossly enlarging the nearest features and shrinking peripheral ones. Similar effects can be observed in a convex mirror or in the back of a shiny spoon.

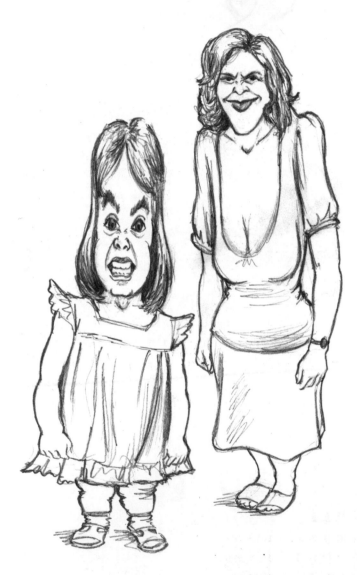

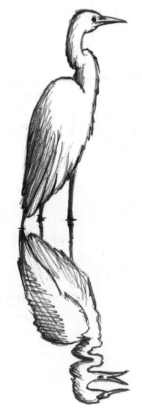

▲ Full-length fairground mirrors provide amusement and amazingly varied distortions of proportion. It is challenging to sketch the bustling excitement of such an environment, but with a camera you can capture fleeting effects and expressions to draw in detail at your leisure.

◄ The gentlest ripples in water produce similarly distorted reflections. They are so fleeting that without the aid of a camera they can never be sketched precisely. What is important is that you capture the general quality of the ripples convincingly.

▼ The glass in very old windows produces interesting reflections. The surface may be rippled or bowed and small panes, set at slightly different angles, break up a reflection into jumbled, abstract compositions.

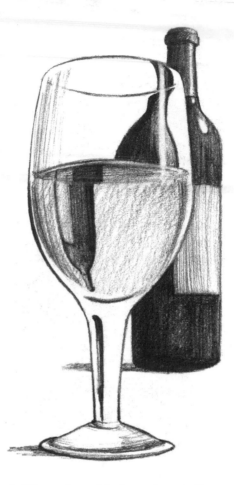

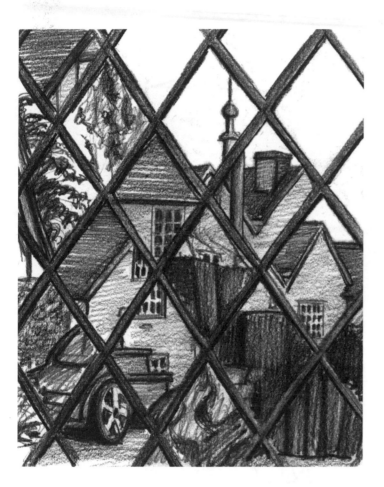

▲ Glass of any kind produces all manner of interesting reflections and refractions. The bottle here is repeated three times when seen through the wineglass: distorted by the curved glass, inverted by the wine, and again in the thicker lens-like glass of the stem.

ARTIST'S ADVICE
It will rarely be necessary to precisely replicate the effects of distorted reflections. Nevertheless, it is worth making some detailed studies so that you can approximate them in sketches and in imaginative illustrations.

Part 2
INVENTION

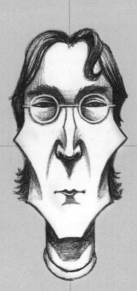

In the first half of this book, inspiration for the drawings came directly from observing reality. With the experience gained from tackling real subjects in creative ways you can now proceed to drawing objects, scenes and figures that do not exist in the real world. That is not to say that we will not continue to explore real-life subjects – indeed, we will depend on them as much as ever to inspire and inform our flights of fancy. The challenge of making drawings without direct reference to a subject should soon feel quite liberating as you come to appreciate the creative freedom your new-found skills will open up for you.

Essentially, the second part of the book deals with illustration. This is a very broad area that caters to many different age groups and markets, but the skills demonstrated in this section should allow you to develop your artwork in whatever direction suits your strengths and interests. We shall take the raw material of sketches, photographs and the imagination and turn them into pictures of idealism, surrealism, caricature and fantasy.

As you work through this section, bear in mind that the examples depicted represent only the tiniest fraction of all possible subjects, methods and stylistic treatments. Cast your net as wide as you can and study the work of artists and illustrators from many different periods and fields. Try to learn something from each, just as they learnt from their peers and predecessors.

Illustrative Processes

Having gained some experience of drawing things as they are in the real world, it should not be too difficult to conceive new pictures in compositions and designs of your own invention, all from the comfort of your desk. Here is a breakdown of the typical stages involved in a simple illustrative design.

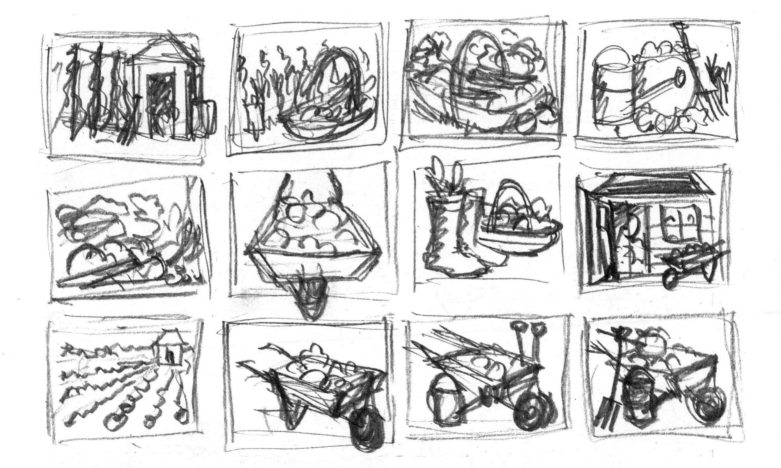

THUMBNAILS

The first stage is usually to produce a number of thumbnail sketches, so-called because they need be no larger than your thumbnail. The idea is to jot down ideas and compositions in an extremely quick and throwaway manner, without fussing over details. It is the basic essence of the design that matters, and this should be quite clear in small scale.

My brief for this job was for a bold, black-and-white design that conveyed the idea of growing vegetables on an allotment. My thumbnails, done on a piece of scrap paper, are virtually indecipherable, but they served their purpose for me.

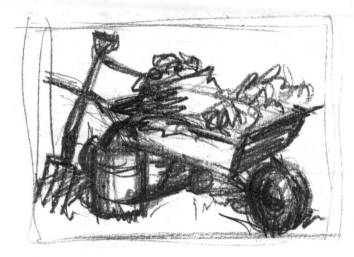

◀ THE ROUGH

Still using scrap paper, I worked up my favourite thumbnail into a more resolved design and established a rough shading scheme. Taking a few minutes to work out ideas in rough form can save a lot of time and headache in the long run.

▶ In building up the detail of the drawing, I aimed to keep everything very simple for this bold design. Other types of illustration may require much more detailed underdrawing.

◀ To ink the outlines, I used a cheap black permanent marker pen. The heavy line of the pen forced me to retain that essential boldness of execution and also shaded the dark areas with a rich black. The waterproof ink would allow for corrections.

▶ Having noticed a tonal imbalance, I added more solid black on the barrow and fork. With a fine brush, I painted on white drawing ink to correct the other mistakes and imperfections and, once it was dry, I used the marker pen again over the top.

Purity of Design

Although most illustrative artwork tends to be produced along the lines of the previous demonstration, there is no definitive method. Just as your choice of materials may determine how you go about creating a piece of artwork, so the type of picture or effects you aim to achieve demand particular processes and ways of thinking. The following examples came out of the processes of successive redraftings and fine-tunings.

It was not difficult to draw the individual silhouettes that make up this design; they are virtually straight copies from old photographs. However, arranging them into a clearly legible and appealing composition was not so straightforward. I drew each on separate sheets of tracing paper and overlaid them in many different positions. Once happy, I stuck them in place and traced the design on a lightbox.

TRACING

For working through the stages of the design process, much time and effort can be saved by tracing. It requires no dramatic redrafting at any stage and allows the work to develop quickly and painlessly. I often use layout paper, which is cheap and lightweight enough to trace through but more opaque than tracing paper.

Here I started with a naturalistic sketch and placed a sheet of layout paper over it. As I traced, I modified the drawing into graceful curves to give the animal a more powerful presence. I repeated the process, this time adding a sense of movement.

When I was pleased with the design, I used a lightbox to lightly trace the outline onto firm paper and stippled the shading with a sponge and poster paint.

Decorative Illustration

The principles outlined so far in this chapter may be taken a step further into artwork that is purely decorative in function. Fabrics, wrapping paper and all manner of everyday items carry decorative motifs that originate from real-life subjects. For this demonstration, I followed the principle of reducing a subject to a kind of symbol of itself and then reinventing it to suit a particular space.

▲ Initially I sketched various poppies in the garden to get a feel for the way they are constructed. I also drew a leaf and some stems and buds, all of which add to a flower's particular character.

▲ I picked a completely arbitrary shape and sketched a pleasing curve running through it. To this I added the very basic forms of some flowers and leaves.

▲ Over my basic guidelines, I started to flesh out the forms of the flowerheads and leaves. I was interested here in filling the space evenly while retaining a very loose flavour of the poppy forms I had sketched.

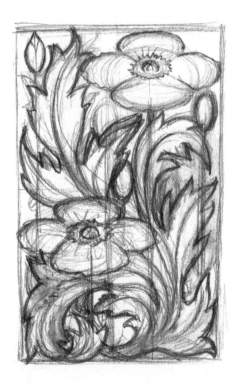

▲ In order for this design to look 'pretty' I wanted to draw every part in detail before committing anything to ink. The result is quite messy, so I made a fresh tracing of this design onto good-quality, clean paper using a lightbox.

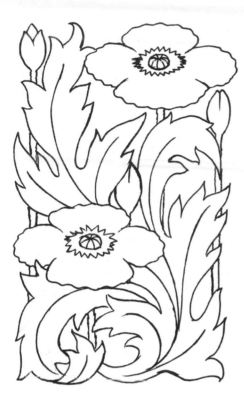

◀ For the first stage of inking I employed the even line of a felt-tip drawing pen. As you can see it looks very weak, but it is amazing what a difference can be achieved by well-considered secondary inking.

▶ With the same medium drawing pen, I went over the lines to give them more weight and grace in their curves. Some solid black gave a focus to the two blooms and distinctive fuzzy marks helped the stems and buds to stand out. Some background dots (rather like poppy seeds) lifted the whole design forward, and then I added some more striations on the leaves, which seemed rather too flat and featureless. To finish, I further strengthened the perimeter to contain the design as a whole.

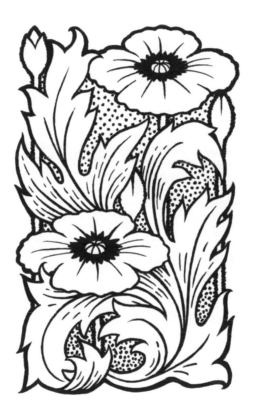

▶ Designs like this can be repeated, using a computer or a photocopier, to make friezes, borders or other decorative schemes.

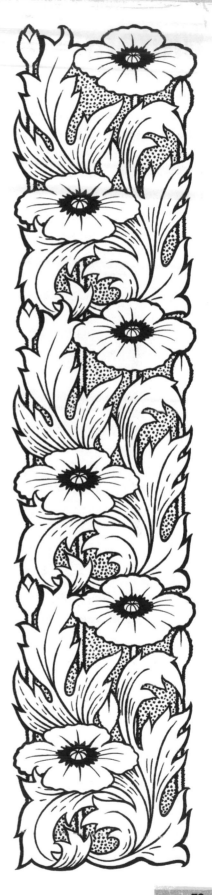

Metamorphosis

Another way of producing imaginative drawings involves developing your ideas directly on the artwork. Often the best results come when an interesting form presents itself and naturally suggests a path to follow. It is best to work with materials that are easy to erase, but most materials can be corrected and reworked when you have gained experience of using them. For now, though, I will demonstrate this approach with pencil, making a drawing based on an old tree that, to my mind, had a very suggestive form.

▲ First I lightly sketched the basic form of the tree and its immediate surroundings. It is a good idea to work from a naturalistic starting point and not impose your vision too soon in the process.

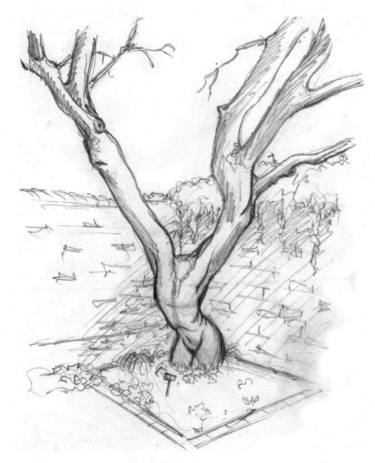

▲ With a darker pencil I picked out the parts of the trunk that most suggested a human torso and gently emphasized the contours accordingly.

▲ I carried on the process up the limbs, which ended in oversized and twisted hand forms. I let the form of the tree dictate all of these changes, trying to incorporate each branch into the design. I imposed the human details out of my head, informed by my experience of drawing the human figure from life, and also carefully observed my own hands.

► For the shading, I followed the lighting direction present. I used curving, scribbly marks to give solid form to the branches and to convey a convincingly tree-like texture.

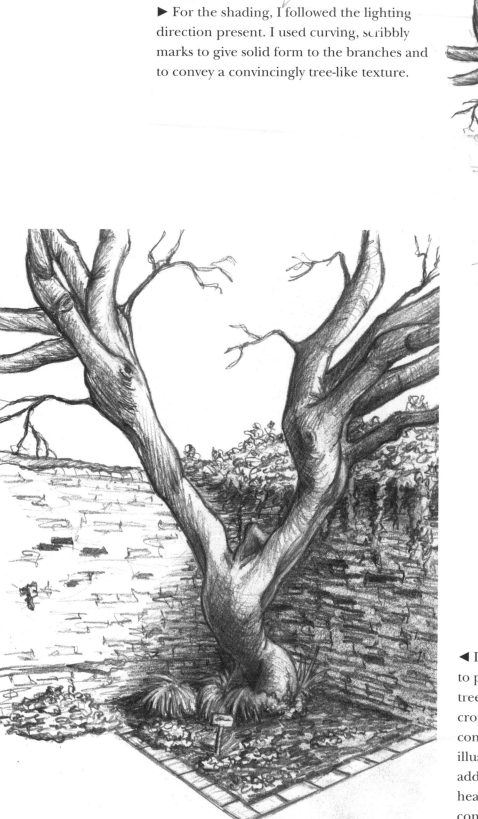

◄ I shaded some background detail to provide a setting and tone for the tree to stand out against. Tight cropping truncated the branches at convenient points to help with the illusion of fingers. As a final touch, I added the detail of a thrown-back head, inviting an emotional connection with the viewer.

Beyond Reality

In the world of the surreal, everyday subjects take on qualities they could never possess in real life, yet the recognizability of the motifs lends the imagery a degree of credence. This is the language of editorial illustration, usually contrived to make a point, but equally adaptable to pictures that exist for no other purpose than to intrigue. The only restriction is your imagination.

A simple and effective introduction to making drawings of invention and fantasy is to combine unrelated subjects in a single drawing. There is no end to the different approaches you can employ to achieve such metamorphoses and there is much fun to be had.

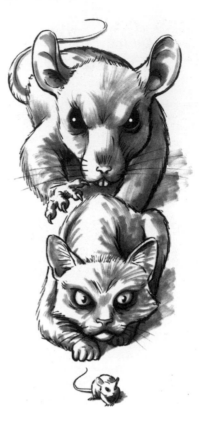

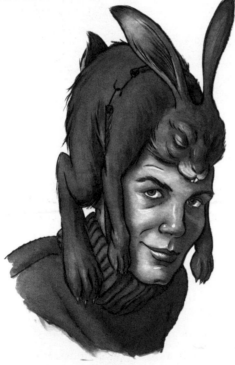

▲ Creative juxtaposition is essentially about bringing two (or more) unrelated things together to create meaning, comedy or visual impact. The concept is extremely simple, yet in practice it can be very effective.

▲ We generally associate power and importance with physical stature. Enlarging familiar objects will increase their standing relative to the things around them, and the reverse is true of reductions in scale.

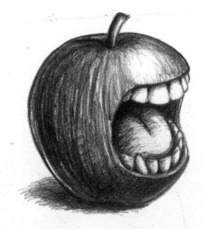

▲ It is easy to apply a surreal element to anything you draw; it need not be clever or polished in its execution to have impact. I drew this on a bus after biting into an apple, referring to my own teeth in the reflection in the bus window.

▲ Repeating a motif can change the connotations of a single image. Here I painted one figure and then replicated it over many layers on a computer.

▲ Every law of physics may be turned on its head by the artist; the only rule is that you should make your pictures look believable. So whatever combinations or manipulations you employ, the drawing language, lighting, perspective and so on must be consistent within the picture. In this case, the consistent ground plane and interaction of shadows are the important factors.

◀ A suit may walk unaided without any logical means of propulsion. But then other times we may allude to the implausibility of an image, for example by including some sparkle effects to suggest a magical element.

Anthropomorphism

It is a human trait to imbue all sorts of non-human objects with human qualities and values, a phenomenon known as anthropomorphism. This can be done as simply as by drawing a face on the front of an object. The illusion of life can be further developed with character and expression in the face and an appropriate sense of movement or action. With human limbs and articulation, the presence of a face may not be necessary at all.

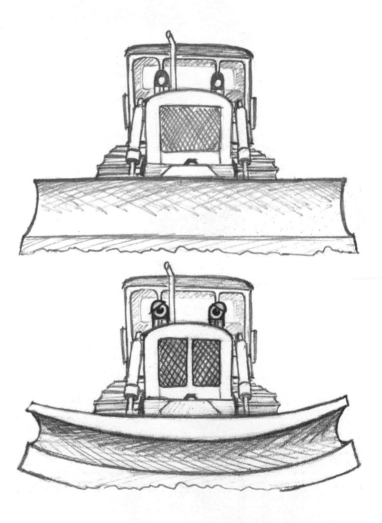

▲ It takes no great leap of the imagination to see the face implicit in this bulldozer, and no more than a few strokes of the pencil and eraser to turn it into a friendly character.

▲ Humanizing animals involves adapting their natural features and characteristics rather than inventing them. A creature may be drawn in quite naturalistic proportions yet convey a sense of humanity with the simple addition of a human facial expression, in this case a smile. A smooth and rounded drawing style also helps to convey friendliness.

▲ Here we see the animal fully clothed and performing human tasks. He is also standing upright and using his paws as if they were hands.

◄ In this design, the animal is almost entirely human in action, character and proportion. It is no more complicated than a cat's head drawn on a human body, yet we still accept it as essentially a cat rather than a deformed man.

Making Faces

Over the next few pages we shall be looking at ways to manipulate the proportions and features of the human head for caricatures and characterizations. However, before you can break the rules you must first be clear what they are, so the first step is to learn some basic guidelines that can aid you in drawing the head in its natural proportions.

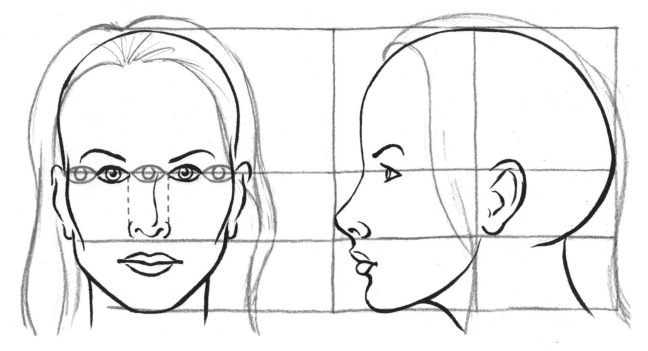

▲ Although every face is different, the basic proportions follow some general rules. The eyes sit about halfway down the whole head and the bottom of the nose and ears sit about halfway between the eyes and chin. The head is about five eyes wide and the nose about one eye wide at its base.

In profile, the head is broader, fitting roughly into a square with the ears set back about halfway. Note here the altered shape of the eye and the angles at which the lower face and neck recede.

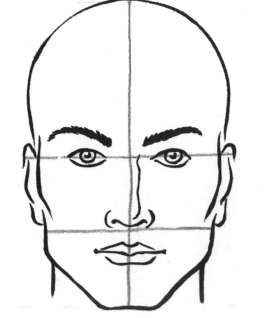

◄ Male faces follow exactly the same relative proportions but differ in the contours of the features. The brow tends to be heavier, the jaw more angular and the neck thicker set. The eyes, nose and mouth may be subtler in their variation from those of the female face.

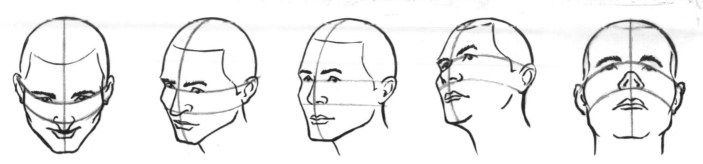

In practice it is much more common to draw faces turned and tilted. The same guidelines can be employed for any angle of view, but they must be drawn to wrap around the egg-shape of the head. Bear in mind that when seen from above, more of the forehead is visible so the horizontal guides should appear lower down the head, and when seen from below the opposite will occur. Likewise, the ears appear to move up and down on the head according to the degree of tilt.

ARTIST'S ADVICE
While this crowd was concentrating on a street performer, I was free to draw them at my leisure. There is no better way to get a feel for all types of faces than to draw lots of them. Carry a small sketchbook and draw faces in coffee shops, on buses and in libraries, for example.

Stylistic Portraiture

The test of drawing faces is to achieve convincing likenesses of specific people. In itself, this can be a tricky business; some likenesses come easily while others may elude repeated attempts. Even so, in the spirit of this book, you should set your ambitions that little bit higher and aim to introduce a creative element into the faces you draw. One way to do this is to think carefully about what drawing language or style may be appropriate for a subject.

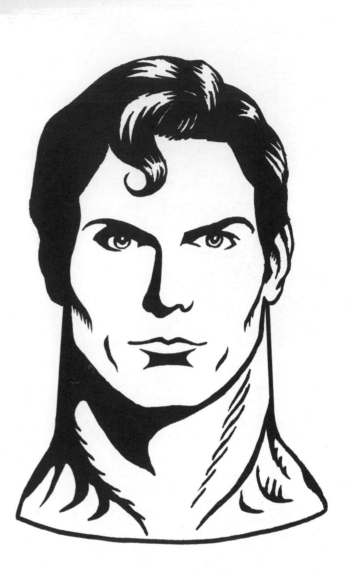

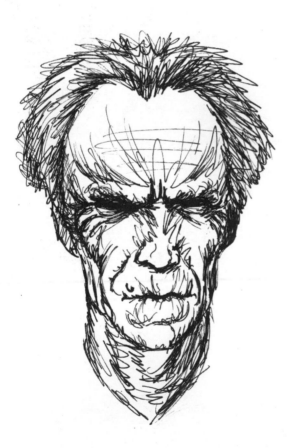

▲ For the actor Christopher Reeve, I have adopted the graphic comic-book style in which his Superman character is typically portrayed. It is not always easy to decide where to put the dividing lines between pure black and white, but it helps if the subject is brightly lit.

▲ To capture the wiry, wizened face of Clint Eastwood I did the inking with a fine felt-tip pen, allowing it to wander across the underdrawing and build up the modelling through the wrinkles.

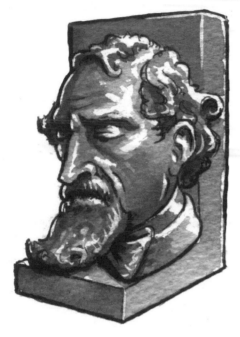

◀ Fittingly for his period and profession, I depicted Charles Dickens as a carved wooden bookend. This is a straight copy of a contemporary portrait rendered with tones and highlights that are consistent across the whole surface.

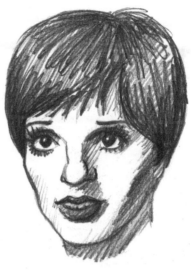

▶ As you can see from my quick pencil study of Liza Minelli, her hair and makeup are very distinctive and accentuate her large eyes and round face. Tracing through onto layout paper, I streamlined the outlines to turn her face and features into a series of symbols.

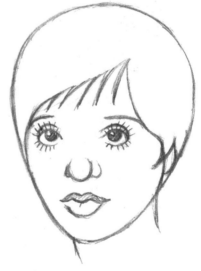

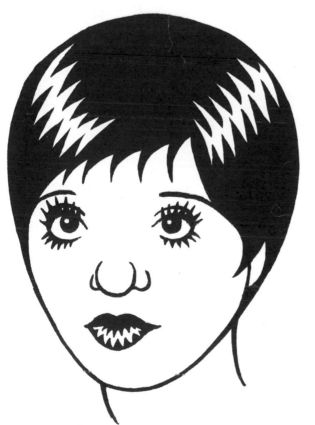

◀ Inking with pen and brush, I further stylized the image. I ignored any naturalistic lighting and turned the highlights on hair and lips into the same kind of zigzag patterns as her fringe and eyelashes. Though I have not altered the proportions or placement of any features here, the dramatic simplification and redesign means this drawing almost counts as a caricature.

Caricature by Stretch

Much of the practice of caricaturing involves such intangible things as experience, feel and trial and error. Just as every face and personality is unique, there are no hard and fast rules, but there are some general principles that can get you started on this rewarding discipline. Here I will discuss stretching the proportions of the head and features in a controlled direction.

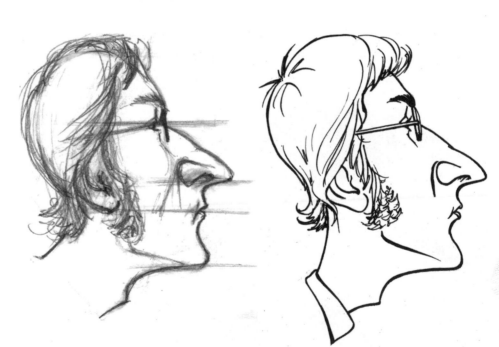

The principle of stretching features can be used in a variety of directions. For this profile of John Lennon, I moved the layout paper laterally as I traced my original sketch, keeping the placement of the features consistent with the aid of horizontal guidelines. I then traced the tracing in the same way until I was happy with the exaggeration. The back of the head is of little interest in a caricature and I drew it much diminished in size.

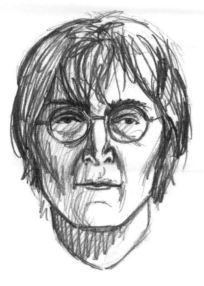

◄ To get a feel for the front view, I looked at many photographs and made a quick sketch. The prominent features for me were the chiselled nose, thin lips and general angularity of the face.

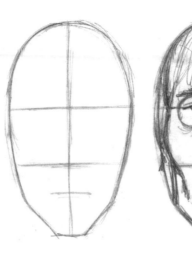

◄ To start a caricature, I drew a rough grid, greatly elongating the lower face to accommodate a lengthened nose. Onto the grid, I roughly put the features in their new placements and made a start on shaping the cheekbones and jaw.

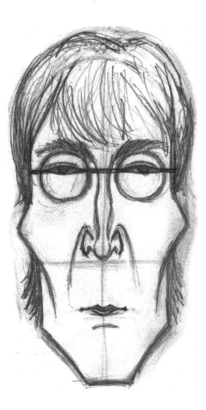

◄ At this stage, it is all about feeling your way into the characterization, reshaping, refining details, erasing and pushing the exaggerations, all the while striving to retain a likeness. Do not be afraid to let your drawing get quite messy while you search for the optimum outlines and contours.

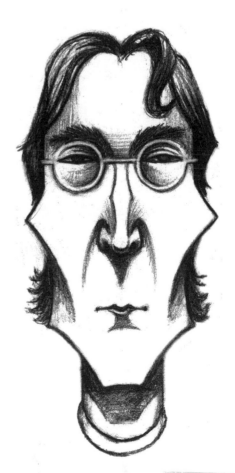

► Somewhere along the way an appropriate treatment for the final image will usually occur. In this case, I elected to continue with the pencil version. I carefully cleaned up the many scruffy marks and shaded with a soft pencil in selected areas to emphasize the angularity of the newly constructed face.

Caricature by Features

Most caricatures are essentially based around the exaggeration of one or two main features, so it makes sense to start a drawing with the dominant part of the face and allow the rest of the likeness to grow organically around it. This method is less controlled than stretching the face, but it usually leads to more interesting drawings.

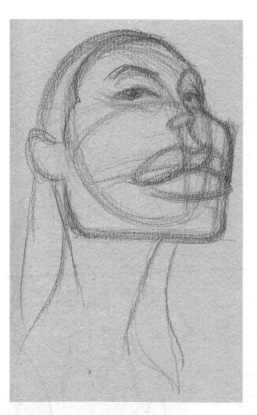

▲ I have chosen to draw Angelina Jolie from a three-quarter view, which lends her refined features a sculptural quality and depth that more formal views do not capture.

I chose tinted, heavyweight paper and a blunted, water-soluble pencil. I started with a rough egg shape with curved guidelines to establish the perspective of the head. Straight away, I drew the oversized lips and then framed them with the actress's firmly shaped jaw.

◀ Gradually I added the other features, keeping them very rough. The important thing is to set them in the right places at the right kind of scale. The blunted pencil and textured paper help to keep things very loose and easily rectifiable.

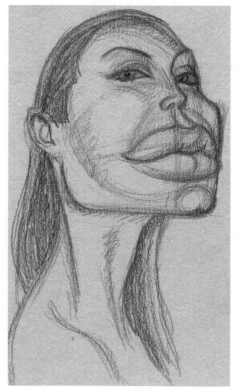

► To refine the features, I sharpened the pencil and started with the eyes, paying close attention to my source photograph. The success of a caricature depends very heavily on the eyes. I made my way around the drawing, picking out the definitive contours from the myriad lines of the underdrawing.

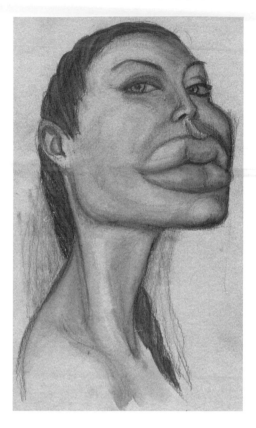

◀ On reflection, I decided to change the hairstyle in favour of one more commonly associated with the actress. Then, with a large, round watercolour brush, I moistened the pencil marks to blend them together, like a watercolour painting. While wet, the pigment can be pushed around with the brush and dabbed off with tissue paper where necessary.

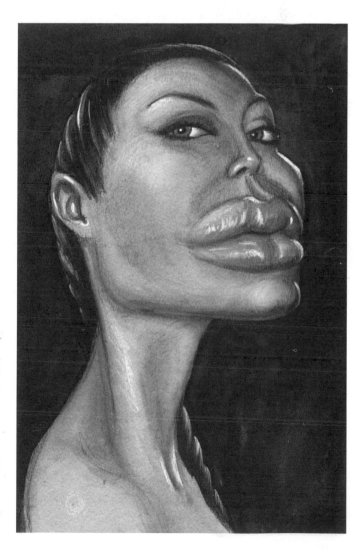

▶ I mixed up a wash of black watercolour to darken the background and then dried the picture thoroughly with a hairdryer. I used a hard eraser to soften the skin tones in places, then went about making small adjustments here and there, defining the darks with pencil and bringing out soft highlights with white pencil. For the final bright highlights, I used white ink with a fine brush.

ARTIST'S ADVICE
Unless your subject has particularly interesting eyes, it is usually a safe shortcut to a likeness if you copy them accurately as a stable point of character amid the grotesque distortions of the rest of the face.

Facial Illusion

Our human psychology makes us particularly attuned to recognize faces. Given enough clues, a viewer can be led to see faces in clouds, half hidden in shadows or masquerading as something else. Playing with this phenomenon, this demonstration attempts to make a caricature in the medium of fruit.

▲ First I designed a rough caricature. Elton John is a good subject for this exercise because his trademark glasses avoid the issue of how to realize the eyes. Also, his image is strong enough to stand being reduced to a few simple shapes.

▲ Tracing onto layout paper, I tried to translate the contours of his features into fruit forms, starting with the obvious parts – strawberry nose, grape teeth, melon forehead and so on. In the process the likeness strayed somewhat, but I hoped to retrieve it in the final drawing.

▶ I traced the design onto clean paper and made a few more changes for the sake of simplicity. I used ink and marker pens for the rendering, touched up with spots of white ink. I deliberately avoided putting very much textural detail into the fruit, trying to strike a balance between the two readings.

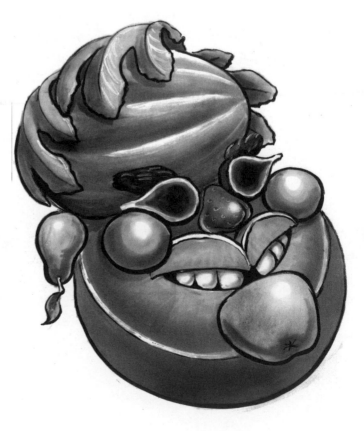

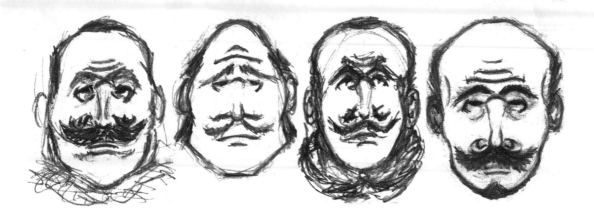

▲ Faces offer us many kinds of illusion to experiment with. Here is another example, based on the Victorian mystery novel *Dr Jekyll and Mr Hyde*. The aim was to design an original characterization for the lead character, with his sinister alter ego lurking inside. To see Mr Hyde, turn the book upside down.

These are just a few of my very rough thumbnails. It took a lot of trial and error to make the characters and expressions work in both directions.

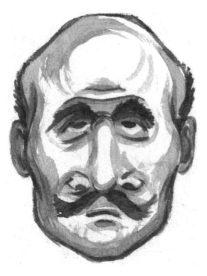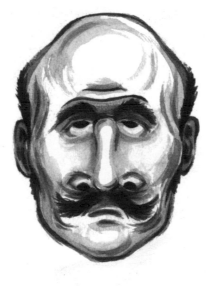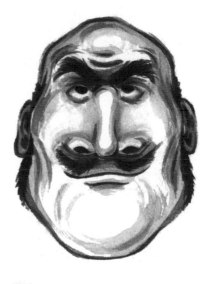

▲ The drawing language was vitally important here. It needed to be quite loose so that some of the marks would read as mere wrinkles in one direction and important features upside down. I used light washes of watercolour applied in visible brushstrokes.

▲ I gradually added more depth and detail to sharpen up the image, but stopped before I became too fussy and risked spoiling the illusion.

▲ Here the inverted head symbolizes the other side of this famous fictional character.

Stylistic Figures

The full figure offers yet more potential to make artistic statements about people. Working from photographs or live models, sketches can quickly be developed into exaggerated takes on a subject, just as we saw with famous faces (pages 90–4). Of course the possibilities are endless, but there is always something distinctive about every individual that suggests a way forward. Here are two different approaches on a similar theme.

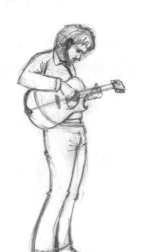

◄ It was the odd, round-shouldered posture of this guitarist that caught my eye, but I failed to capture it successfully in my initial sketch.

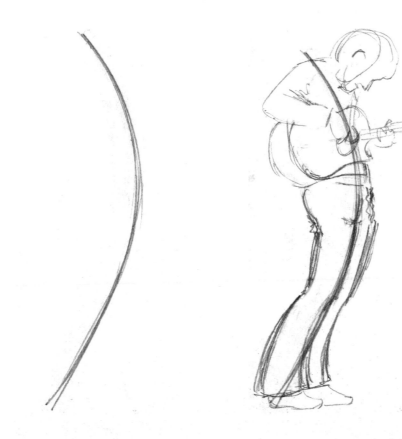

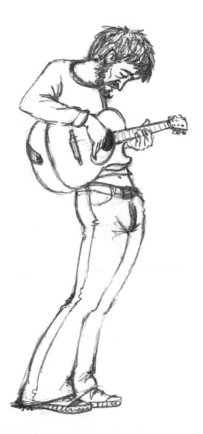

▲ My first step in developing the pose was to draw a sweeping curve to build the figure around on my layout paper. This is known as an 'action line', more common in drawing dynamic figures, but equally useful as a guide to a static posture.

▲ I traced the figure to follow the action line, moving the paper as necessary.

▲ With the basic figure in place, I could have a bit of fun redrafting parts of him into a more intense, undernourished hippy type.

◄ The feature of this figure that stood out for me was the way the guitarist curled himself around his instrument.

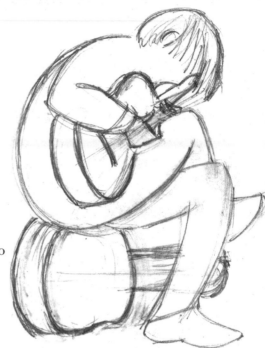

► As I traced through onto layout paper, I moved the paper around to follow pleasing curves and exaggerate his posture.

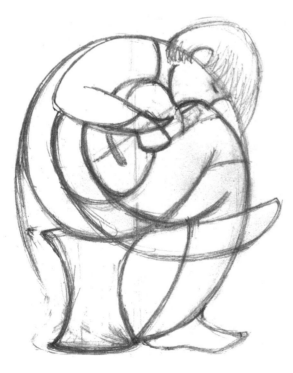

▲ With the second tracing I further refined the forms, making them conform to a series of curves that ran into each other.

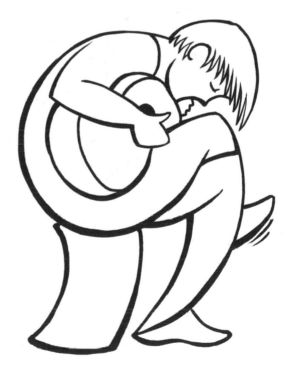

▲ Happy with the overall balance and rhythmic flow of the design, I committed it to ink, tracing again onto fresh paper using a brush pen.

Invented Figures

Having learnt to conjure up faces and characters out of the imagination, it is likely that you will want to develop them further by giving them bodies. The human figure is a complex machine; complex in its structure and proportions, its range of motion and gesture, and its diversity of build. But in essence, bodies can be simplified down to a basic framework that is common to all, much like the egg-shape with which we begin a drawing of the head (see page 86).

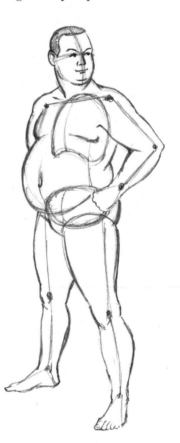

◀ Before drawing a figure without reference to a model or photographs, an illustrator will first draw a basic working skeleton: ovals for head, ribcage and pelvis, all the main joints, and, crucially, the spaces and angles in between. The skeleton should carry all the necessary information about proportion, pose, body language and perspective.

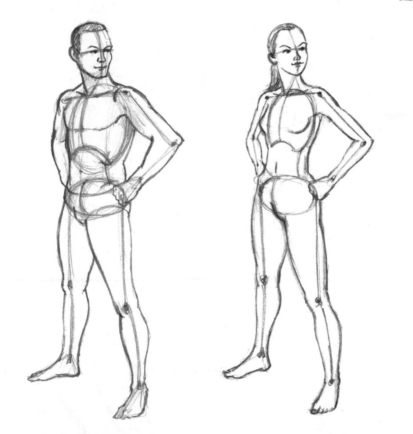

▲ The task of fleshing out the skeleton into a convincing figure should be relatively easy. So long as the skeleton is well posed and proportioned, the odd stray contour will not be very noticeable. Pay particular attention to heads, necks, shoulders and hands – not only are these the most visible parts of the clothed figure, they are also the parts that are most often drawn incorrectly.

▲ Exactly the same skeleton can be used to draw adults of different builds and sexes. You can broaden the ribcage and hips for a very heavy figure, but the skeleton's pose and proportions remain generally the same.

ARTIST'S ADVICE

The best way to become fluent with inventing skeletons is to draw lots of them in many different positions and motions. They do not take long to do and they will quickly develop your eye for correct proportion and posture. Remember that unless your skeleton looks comfortable and natural in its pose, it will be a struggle to make a final drawing convincing.

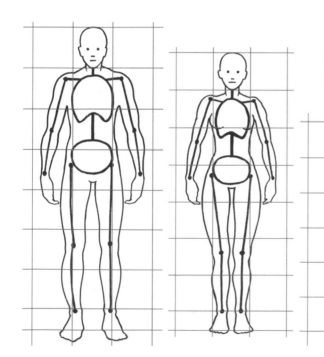

Regardless of height, build and sex, adults are generally the height of around seven or eight of their own heads. Children of ten may be more like six heads tall and toddlers are typically about five heads tall. Artists and illustrators measure figures on this scale to maintain consistency of proportion within each figure. You may like to refer to this diagram when constructing figures of your own. You can see at a glance, for instance, that a man's shoulders are roughly two heads wide, a child's legs three heads long, a woman's legs four heads long, and so on.

Costume and Character

Learning to draw figures from the imagination is all very well, but for them to serve any artistic function they must be given personality and purpose. Unless you want to appeal to certain niche markets, your figures will first need to be clothed. Dressing a figure is not so easy as it may seem. With experience, you will be able to draw clothed figures straight from a skeleton, without going through the nude body stage, but the task is aided greatly when you have a good idea of the contours of the body underneath.

▼ Here are the figures from page 98, each clothed unconventionally to demonstrate the effect of costume on our perception of character. These costumes also represent the main types of fabric you will need to develop a feel for.

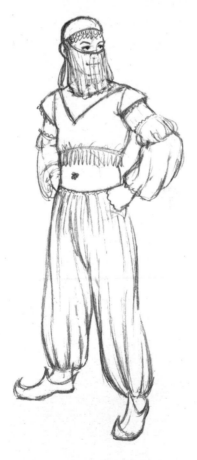

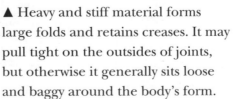

▲ Lightweight, floaty cloth such as silk or muslin falls into large folds and tube-like structures, which are pulled downward by gravity.

▲ Heavy and stiff material forms large folds and retains creases. It may pull tight on the outsides of joints, but otherwise it generally sits loose and baggy around the body's form.

▲ Tight-fitting, stretchy fabric closely follows the form of the body. Where it wrinkles inside joints, the folds are small. Any seams and flaws are likely to be quite visible.

◄ As with so many aspects of drawing, a simple approach to costume can be very effective. If you can capture the right feel for a style of clothing, close attention to folds and wrinkles can be sidestepped altogether. In this illustration of Jeeves and Wooster the clothing is little more than a few outline shapes, but it reads as convincing period costume.

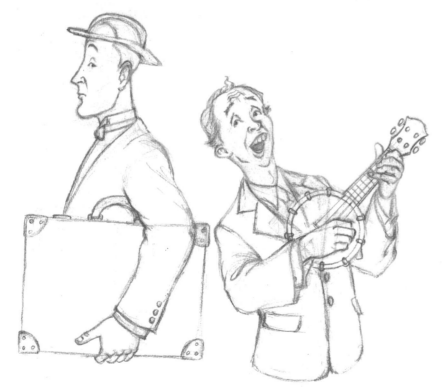

▲ Simplicity of design does not come without some rigour, however. The underdrawing demonstrates how I initially drew the clothing in detail to ensure that the resulting silhouettes and arm positions would work.

ARTIST'S ADVICE
It pays to do some research into costume. Finding photographs and illustrations to refer to will nearly always reveal some odd details and props that would not otherwise occur to you. Hairstyles and small details can add a great deal to an authentic characterization.

Character and Expression

Drawing figures from the imagination is a
challenge in itself, but there is yet more to
consider when infusing them with life and
character. Not only must poses express the right
actions and attitudes, but they should be
supported by expression and characterization.

▲ The experience of drawing real faces, through
portraiture and caricature, can be employed in
inventing new faces and giving them character and
expressions. Diverse though people are, many do fit
into easily discernible types, which are often used in
illustration and cartooning as a kind of character
shorthand. Drawing types is a great way to practise
capturing expressions, whether overstated or subtle,
and will also build up your repertoire of stock
characters. In many fields of illustration this is a
requirement. It is also rather enjoyable.

► It is not always easy to make figures interact physically with each other and their environment. Constructing a scene like this may require lots of small adjustments before taking it to final artwork.

ARTIST'S ADVICE
Keep a mirror on your desk and observe yourself making the expressions you want to capture in your characters. It is not difficult to transfer your expression onto different features and they will be all the more believable for it.

▼ Apart from working hard on the costumes for this scene, I also tried to give each figure a distinct personality through pose, gesture, expression and of course their facial features.

Drama and Narrative

Drawing figures in a setting with interaction between the elements inevitably generates an implicit narrative. At heart, that is what much illustration is about – telling stories. A visual story may depict a single moment in time, but then all the details you choose to include add to the background story or meaning of an event. Other narrative illustrations may show a single scene from a larger story or aim to summarize a whole book in one telling image. In any of these cases, the illustrator can get the most out of the subject matter by emphasizing the action or emotion to create drama.

▲ Macabre images of fear, torment, and evil deeds are bound to arouse the interest of the viewer. A sinister figure will add to the intrigue, especially if he or she is shrouded in darkness or otherwise hidden from clear view.

◄ There is not much going on in this image, but we know exactly how the man feels from his expression and pose, along with the high viewpoint, which has the effect of making him seem small and suppressed. The overflowing desk and ringing telephones also give us clues to his general situation or background story.

▶ It does not take much to get people guessing, and once questions are raised, they are naturally keen to know the answers. Just like storytelling, an illustration can set up a sense of mystery and embellish it with an appropriate atmosphere. Intrigue is an important tool when the aim of an illustration is to attract readers to a story or article.

◀ Bright lighting against a dark setting is a great way to focus attention where you want it, but there is much more to be gained from bold lighting. It can be effective in creating atmosphere, mystery and horror, and brings a sense of gravity even to playful images such as this.

A Sinister Illustration

Organizing all the elements that make up an illustration can take a lot of redrafting, especially when there are clients involved who have their own ideas. The following demonstration is typical of the kinds of stages a design may go through. The brief for this CD cover called for a sinister figure and black cat in front of a full moon and burnt-out building.

▲ Having done many thumbnails, I chose the best to work up into rough compositions for the client's approval. I gave each of the elements a similar weighting in the scene and left areas of undetailed space to allow for a title and other lettering to be dropped in later.

▲ The client decided to combine elements of each rough and to give the cat greater prominence in the scene. I drew a simple revised rough to ensure that everything was approved before committing to final artwork.

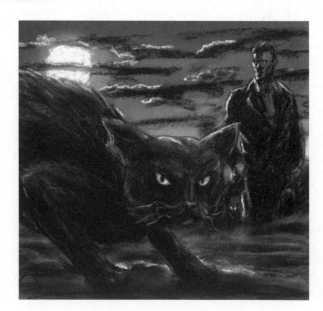

▶ Because dark and light would be so important in this picture, I produced a tonal rough for my own reference. This quick chalk and charcoal version allowed me to check that the picture would work in terms of legibility and tonal balance.

◄ The tonal rough showed me that the cat's body occupied too great an area of the picture and that its pose was looking clumsy. In redrafting the scene for the final artwork, I changed the pose and the naturally lower position of the head allowed space to include a suggestion of a building in the background.

ARTIST'S ADVICE
In portraits, caricatures or other illustrations in which a head is the dominant feature, it often works well to place one of the eyes at a midway point between the two outer edges. This device has been used for centuries to create an informal balance in portrait compositions.

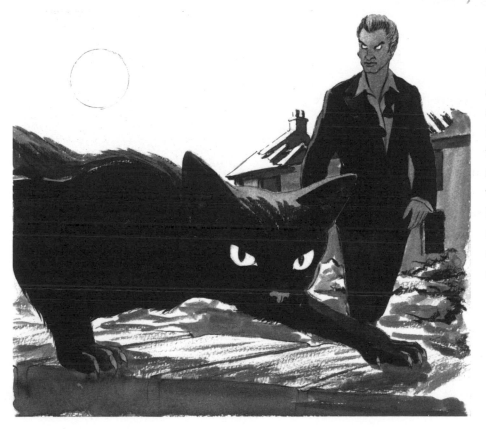

◄ With brush and black ink, I outlined the main details and filled in areas of solid black. This meant covering over some carefully considered drawing, but it would make for a more confident image in the end. While the brush was still loaded with ink, I dipped it in water and roughly painted some background detail and surrounding tones with grey wash. This encouraged speedy work, which would help to avoid an over-laboured final picture.

►

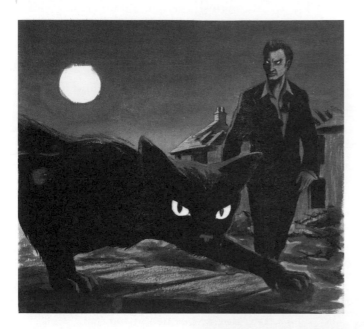

◄ To fill in the sky, I turned the drawing board upside down and rested it at an angle on my lap. With a very soft, broad brush, I washed diluted ink in horizontal strokes over the sky, starting at the horizon. The pigment gathered towards the bottom of my working area, resulting in a gradated tone. With practice and care this can be achieved seamlessly, but I only needed a rough finish here. I also filled in more tones across the whole picture, leaving no white except for the very brightest spots.

► To paint the clouds, I loaded a thin bristle brush with dark grey ink and then wiped the brush almost dry on some tissue paper to produce wispy, soft-edged marks. I dry-brushed with white ink for the highlights on the clouds and on the cat.

I spent some time on a few remaining details, building careful layers of watercolour in the man's face, modelling the cat's paws and washing a hint of gradated tone on the eyes. With pure white ink and a fine brush, I added the sharp highlights around the man and building and finally the cat's whiskers, white in the moonlight and black in the shade.

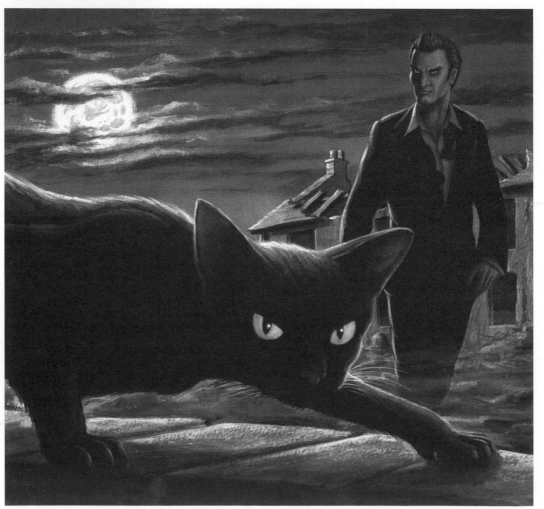

Developing a Scene

So far, most of the imagery in this section has grown out of thumbnails, roughs and careful underdrawing, but some kinds of subject matter may be better approached in different ways. In this demonstration I allowed the composition to develop through the painting process. Remember that there are no rules governing how an image is produced; it is the end results that matter.

▲ The very loose brief for this illustration dictated only a ship at sea being attacked by a many-tentacled monster. Working from a photograph of a ship, I drew it roughly in charcoal straight onto heavyweight watercolour paper. Setting the ship at a diagonal breaks up the picture space dynamically and suggests a suitably stormy sea. As I added the tentacles and smoke, I shaded them with the charcoal and very quickly had a full tonal drawing to respond to.

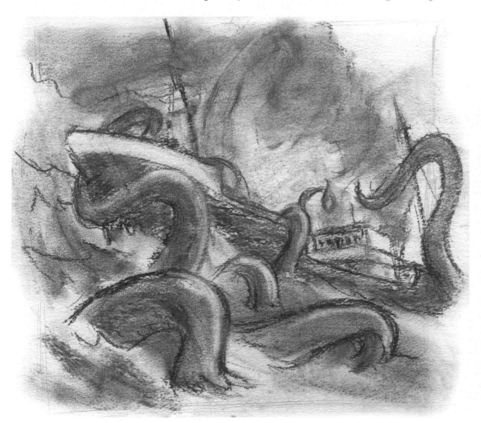

◄ Charcoal being so unstable, it was easy to smudge away some of the tentacles with a fingertip and draw new ones until I was happy with the composition. The dirty marks all over the paper would soon be absorbed into the painting.

►

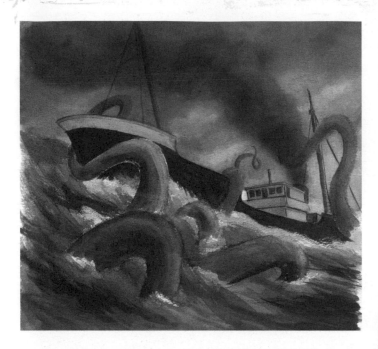

◄ Using a fairly large bristle brush (No. 5 hog's hair filbert), I blocked in the main areas of tone with washes of black watercolour, covering the paper loosely and quickly.

► I decided to make the tentacles more alien-like and took inspiration from pictures of entrails. I added the new drawing with white water-soluble pencil. To correct the perspective on the boat I mixed some paint with white ink, which is opaque enough to cover well. I also used white ink to brighten the sky around the cabin and to introduce some highlights in the clouds and sea.

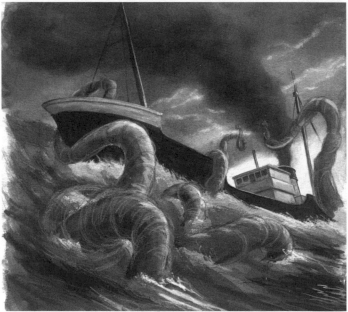

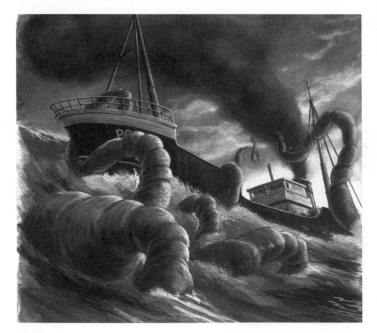

◄ With all the elements established, I painted in the tentacles and added details on the ship with paint, inks, and water-soluble pencils. With experience of using a variety of materials it becomes instinctive to take advantage of their particular qualities for certain effects.

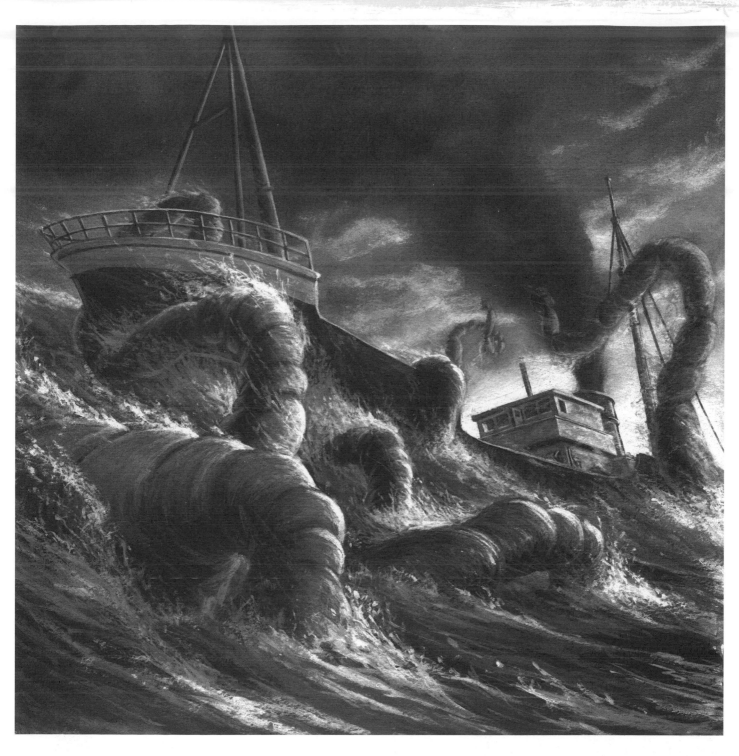

▲ To finish, I adjusted some tones here and there with watercolour washes and used more white and grey ink to add the splash and spray effects, before framing off the picture into a neat square.

Heroic Character Design

With the last two demonstrations we are veering into fantasy illustration, a term which encompasses a broad range of fictional traditions and styles as well as the more typical worlds of science fiction, dragons and wizards. Whatever the subject matter, the principles are interchangeable.

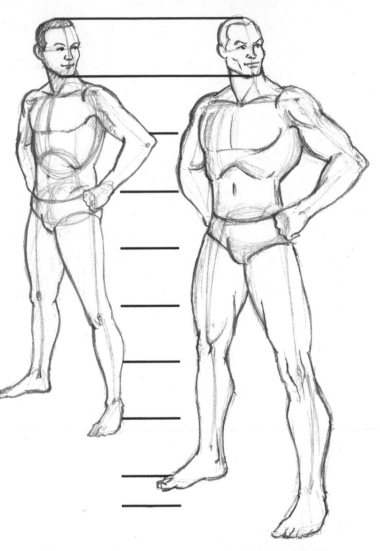

▲ A figure who is endowed with superhuman build need not be depicted in an overly macho or dramatic manner. Elegance of proportion can lend a character presence without the need for pantomime gesture.

▲ Where the standard heroic fantasy figure differs from an ordinary person is all in the proportions. As we saw on page 99, most adults are around seven heads tall, whereas the hero may be eight, nine, ten or more heads in height. He will be broad at the shoulders and narrow at the hips and his muscles will be bulky and well defined.

◄ Everything that applies to male heroes goes for women too. Female warriors, superheroes and the like will be eight or more heads tall, well-muscled and heroic in pose and expression. Others may be more feminine and elegant, but nearly always impossibly tall, much as in the world of fashion illustration (see page 66).

► You are not obliged to keep to the well-worn conventions of heroic characters. None of this is real, so let your fancies run free. Think of your characters as people with personalities, tastes, flaws and background stories. Who is to say that imaginary heroes cannot be old, educated and suave, or possess any other quality the artist chooses to give them?

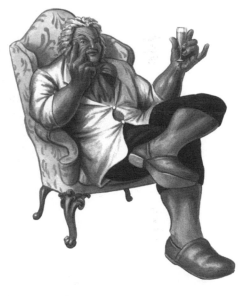

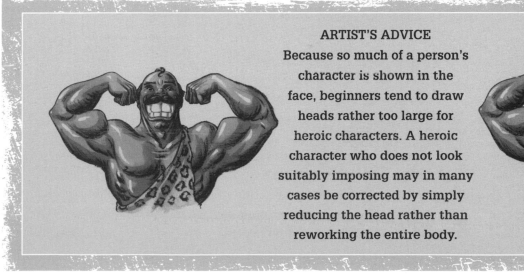

ARTIST'S ADVICE
Because so much of a person's character is shown in the face, beginners tend to draw heads rather too large for heroic characters. A heroic character who does not look suitably imposing may in many cases be corrected by simply reducing the head rather than reworking the entire body.

Other Fantasy Characters

As well as heroes, fantasy stories abound with all manner of figures of wit and mischief – far too many to cover in the limited space of this book. However, the following examples can be adapted to suit many diminutive character types, the differences often being merely in the final details.

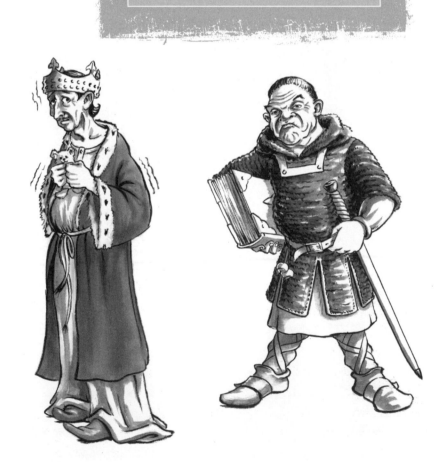

▲ Two very different characters can be seen in these skeletons. Both are around five heads tall, but one is very much broader in the head, chest and shoulders, his build being somewhat reminiscent of a bulldog or gorilla. The posture of each gives them attitudes appropriate to their builds.

▲ In working up the design of these characters, I looked into medieval costume and adapted it to suit. This kind of research nearly always throws up ideas and results in more convincing images. Here, the characterizations and attitudes mirror the relevant body types. However, it would be equally valid, and perhaps more interesting, to invert those conventions.

◄ To give this perky little chap a degree of energy in his pose, I started with a strong action line to run through the whole body, and built the skeleton around it. The proportions, at around five heads tall, are similar to those of a small child, but overlarge hands and feet help to make it seem more adult from the start. Already a sense of character and expression should be apparent in the skeleton.

◄ The face being so important in quirky characters, I drew this first. This would influence my drawing of the rest of the body. In roughing out the main masses of the body, I reduced the ribcage and hips, which are now much smaller than the head.

► In adding clothing and refining the details, I decided to change his left arm. Introducing a pencil, an object of recognizable size, establishes a sense of scale.

► After a few more tweaks the figure was ready to be turned into a final artwork, in this case using black ink and a couple of shades of grey marker pens.

Non-Human Character Design

Folklore and mythology are alive with superhuman beings and fabulous beasts that have been a rich source of inspiration for artists and illustrators over the centuries. Nowadays, such creatures are generally only found in children's stories or fantasy adventure comics and films. As such, the whole genre is often overlooked, or looked down on, by 'serious' artists, but there are few subjects that offer such scope for invention and genuine enjoyment in imaginative drawing.

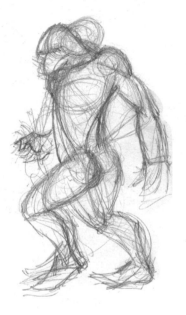

▲ Try to keep your options wide open and let the drawing develop as you go. It is probably best not to start with a skeleton because that would tend to make the proportions and the pose too rigid; it is preferable to find a random seed of inspiration and get some marks down on paper. As a starting point for this design, I very roughly sketched the form of a standing chimp, copied from a photograph, using a hard pencil.

▲ I did not want this design to end up looking like a chimp, so I started to play with the posture and form, increasing the arch of the back, pushing the head forward and so on. It is useful to generate a tangle of lines like this to keep the design fluid and prompt ideas.

▶ With a softer pencil, I selected the contours I liked out of the myriad guidelines. After erasing around the edges I was left with a fairly clear outline that suggested a certain attitude and personality.

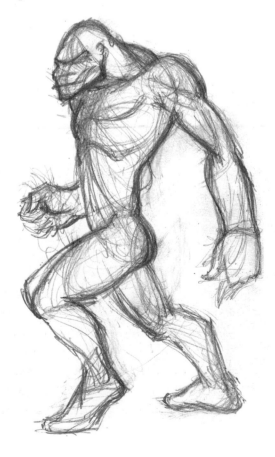

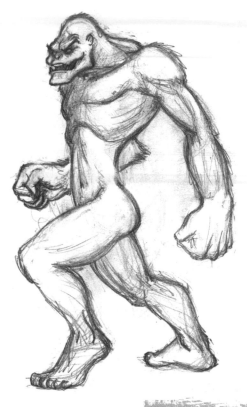

◀ I refined the form of the body and then switched my attention to the head and drew a suitably threatening kind of face that seemed right for the body type, using similar curves and angles to make it a bit ape-like. In a cohesive design, each section or detail influences the design of the whole and vice versa.

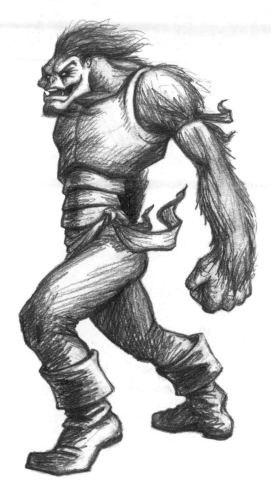

▲ Clothing and rendering a figure affects its character and background story greatly. The stylized armour sets this figure very much among sword and sorcery clichés, but what if he were given floor-length robes, a police uniform, or a toddler's romper suit? If he were hairless, scaly or even see-through, the differences would be dramatic.

ARTIST'S ADVICE
Start your monster drawings in the middle of a fairly large sheet of paper, perhaps A3 size (60 x 42 cm/ 23½ x 16½ in). Leave plenty of space for the character to grow in any direction.

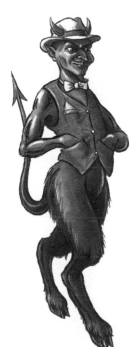

◀ Many of the gods, demons and monsters of mythology are human-animal hybrids. Beings such as centaurs, werewolves, the Minotaur and so on have been depicted countless times, but there is always scope for a new take on these age-old subjects. My illustration of this satyr, or devil, shows him as a cheerful, crafty-looking character, basically goat-like below the waist and human above. Others might blend the two species throughout the entire body. He could be made to look monstrous, menacing, debonair or cuddly. How would you draw him?

Inspirational Devices

There are times when we all suffer from 'artist's block'. The prospect of designing an entirely new life form straight out of your head is likely to bring about such a block – but as you discovered in the first part of this book, inspiration is easy to come by once you grasp the process.

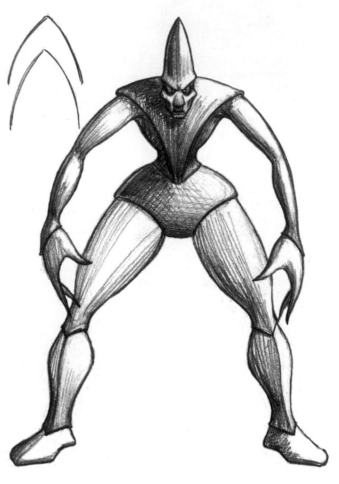

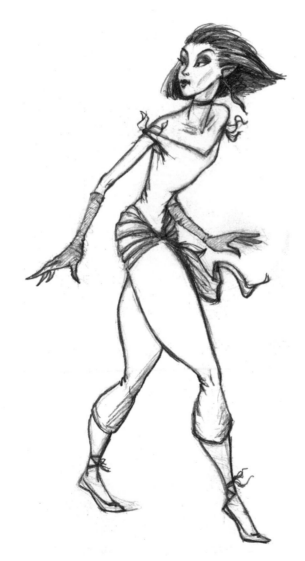

▲ When I thought about drawing a space alien the first thing that popped into my head was *Star Trek*, so I jotted down the gothic arch shape of that TV programme's logo. With that decision made, the alien grew very quickly. It helped that I went for a symmetrical front view. Formal profile views are also relatively easy to design around.

▲ I often spend rather too long trying to decide on poses and what to do with the arms, hands and legs. For this design I gave myself a head start by basing the drawing around a pose I came across in a fashion magazine. The pose suggested the form and the character.

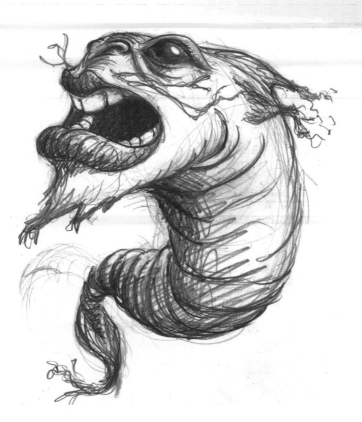

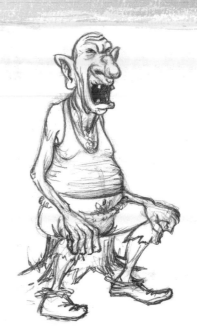

▲ The face here is based on a sketch of a gargoyle from an ancient building, so that was the starting point from which I imagined a suitable body to match.

▲ It is often the little human touches given to fantastical creatures that work so well on viewers' imaginations. With that in mind, my starting point here was a big ugly human mouth. Why it ended up taking a fish-like form is a mystery to me, but then that is part of the pleasure of this kind of subject.

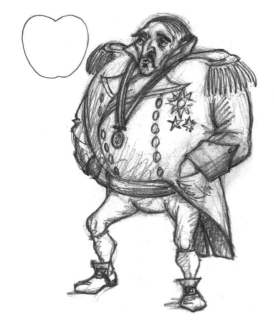

◄ Here I started with an apple shape. As a figure emerged, I thought of a bird puffing out its chest with folded wings and trailing tail. That then developed into a Napoleonic coat, the chest crammed with medals and shiny buttons.

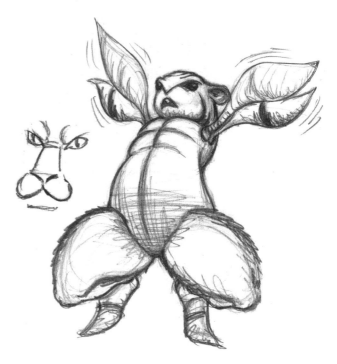

▲ This strange creature came about from my looking at big cats for a scary monster design. I imagined a helpless animal that could replicate a fearsome face to scare away predators. The resulting design is not exactly fearsome, but certainly original.

Blots and Doodles

It is not uncommon for people to see landscapes in the clouds, faces in rumpled cloth or human figures in gnarled old trees (see pages 80–1). Leonardo da Vinci used to gaze at the crumbling plaster of a studio wall and pick out whole marauding armies doing battle in the play of light. Such inspiration can be easily found, or created, to unlock new doors in your imagination.

▲ If you concentrate your gaze on a textured surface it does not usually take long for faces to start peering back at you. For example, here is a photograph of a bush in my garden, taken at twilight when the shadows are deep and the imagination is on full alert.

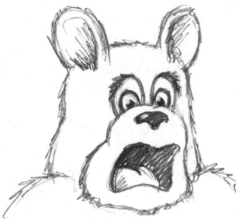

▲ To me, this frightened teddy bear was immediately visible in the rustling foliage.

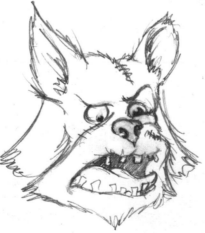

▲ Then, as I looked harder, the light changed and the breeze rearranged the features into something more sinister.

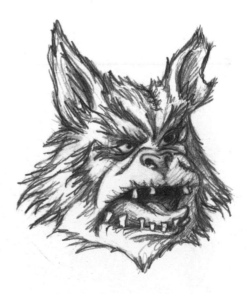

▲ Back in my studio, I worked on the face and took the characterization another step further.

◄ In the Rorschach test used by psychologists, patients' interpretations of inkblots are analyzed. To create your own inspirational inkblots, moisten some heavy paper with a broad brush and water and lay it flat. Load a brush with diluted ink and splatter the paper randomly, allowing the ink to spread. You could also tip the paper to help the ink run, or, for a symmetrical blot, fold the paper in half and press down hard.

► Stare into your inkblot and allow it to speak to you. Turn it round, hold it up to the light and squint your eyes until improbable visions like this jump out at you. When you see something interesting, use some layout paper to trace off what you see. Follow the inkblot as closely or as loosely as you like.

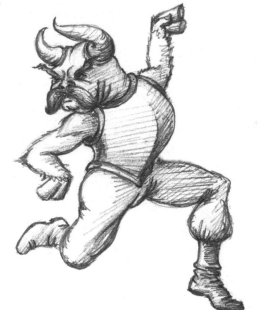

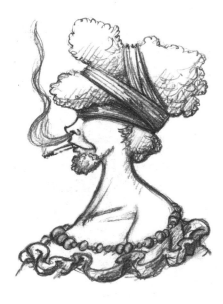

▲ Look also at the 'negative space' around and inside the inked areas.

◄ For a more direct approach, work straight onto the surface of the inkblot. Here I used inks, pencils and watercolour to cajole this image out of the blot. Once you start looking there is seemingly no end to the possible visions. I can see many more things in this one, and I have not even turned it round. A crocodile, a gibbon, a fish, a boggle-eyed bug. . . what can you see?

Fantasy Landscape

All of the inspirational sources and devices that we have seen for drawing fantasy characters can also be used for creating imaginary worlds. Anything that stimulates the imagination is a valid starting point, even childish scribbling.

▲ Having found some paper with an unusual mottled surface in a craft shop, I wanted to take advantage of the texture for an alien landscape. Without any preconceptions, I closed my eyes and randomly scribbled over the paper using the point and the side of a soft pencil.

▲ After studying the scribbles, I selected and defined some of the more interesting lines. These would form the framework of the drawing yet to emerge.

▶ As I developed the guidelines into structures, they gradually took on organic forms, rather like seashells and corals. I added some rudimentary windows to give these forms the scale of buildings and imply the hand of alien intelligence in their creation.

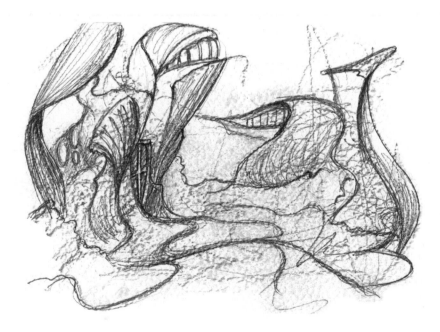

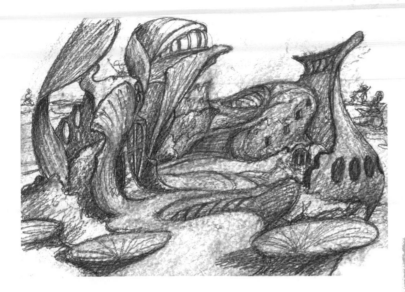

◀ At this stage I wanted to give everything a definite form. I decided on the direction of the light and put some tone into all the areas that would be in shadow to form a three-dimensional space. This required a lot of decisions about how each structure would curve and connect with others.

> **ARTIST'S ADVICE**
> Repeating shapes, details and motifs through the drawing gives the design a cohesive feel, however wacky the results may be.

▼ It took quite a long time to refine the rough shapes into presentable artwork. I picked a small figure out of the scribbles and then erased the remaining unwanted marks. I deepened shadows in the foreground and softened tonal contrasts towards the background to give some aerial perspective. In developing shapes and surfaces I was aided by the paper, which provided an effective grainy texture.

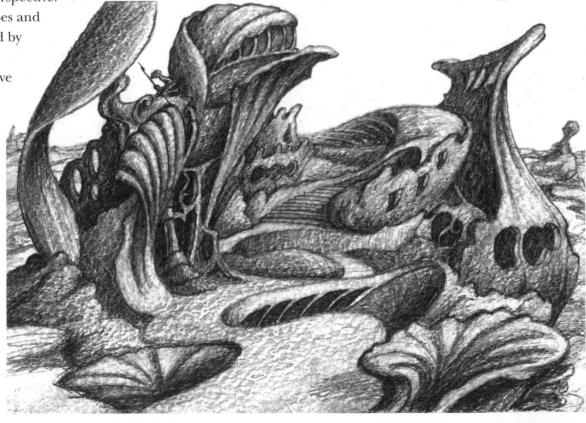

Landscape Design

When you have a fairly clear idea of the kind of landscape features you want to draw, you can orchestrate the space just as you would for any other composition. To help you to make the many decisions involved, employing a compositional device can be invaluable (see pages 46–7). You need not stick to them, but starting with geometric shapes, curves, diagonals and so on will get the ball rolling and ensure that you have a graceful or imposing foundation for the design.

◄ After trying out different curves on scrap paper I arrived at these, which, to my eye, have a pleasing, harmonious feel. They may be nothing more than four simple lines, but with a little contemplation they may suggest no end of drawing possibilities.

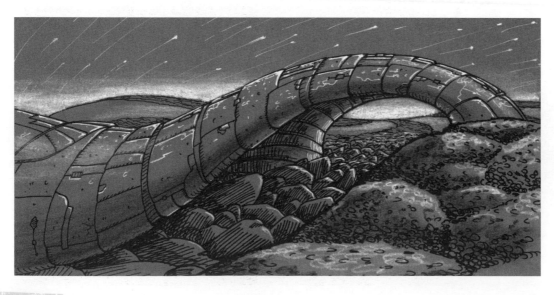

◄ Following the curves closely, I devised this science-fiction type of landscape. For a comic-book feel, I used felt-tip drawing pens for the line drawing and a white drawing pen for the highlights. A few strokes of chalk and charcoal brought out some gentle tones against the plain grey paper.

► A compositional device can be interpreted in many ways. Here the dominant curve became an old cottage and other curves informed the rolling fields and hills in which it is set. Much of the detail for this drawing came from an old woodblock print, the feel of which I tried to capture in the loose black ink brushwork.

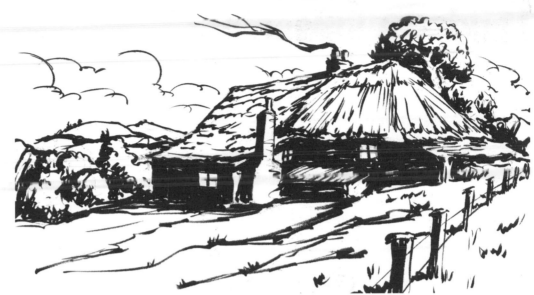

◄ Before starting this drawing, I found an atmospheric picture of a mountainous landscape. From that single reference source, I could very quickly transfer the landscape details to fit into the shape of my compositional curves. With the rugged texture and heavy pencil and ink tones, the original curves are no longer immediately visible.

► Again the original curves are hard to see in this industrial roofscape, but they provided a convenient starting point. I looked at several old photographs of Victorian industrial towns to inform the chimneys, silos and rooftops that are assembled here. For a grim, dirty feel, I shaded roughly and rapidly with very soft pencil and smudged many parts with a fingertip.

Making a Statement

In many art schools, drawing and illustration come under the banner of 'visual communication'. Of course there will always be a place for artwork that exists purely for its aesthetic merits, and illustration is very often supplementary to a story or text. Even so, the illustrator should strive to bring out that extra dimension of communication by using visual signals to carry a message, inspire thought or provoke a response.

▲ EXAGGERATION

It can surprisingly easy to confuse the point you wish to make. Exaggeration is a good way to avoid any ambiguity. This old couple with their clothing, poses and expressions are clearly huddling round the candle out of necessity, rather than for any romantic reasons. However, with serious themes, be aware that exaggeration can easily look cartoon-like and unintentionally light-hearted.

▲ WHIMSY

The brief here called for an ostentatious Gothic fireplace. As it was for a light-hearted book I included a joke element in the form of an old electric fire, which looks ridiculously small and ineffective in the fireplace and highlights the scale and pomposity of its surroundings.

▲ PROPS

The magnifying glass serves as an extra point of interest in this portrait of Aldous Huxley. It is fitting because he was plagued by very poor eyesight, and with its inverted image it speaks of the peculiar and insightful view of the world the author expressed in his writing.

▶ CONNOTATION

This simple twist on a ship in a bottle accompanied a magazine article about counterfeit medicines. The combination of pirate ship and medicine bottle immediately suggests drug piracy and the skull motif denotes poisonous contents. Then there are the secondary connotations: smuggling, riches, plunder, threat, overseas trade and so on.

◀ ATMOSPHERE

This scene of awkward teenage fumblings behind a holiday chalet is given a magical slant by the shapes of the couple's shadows. We can imagine that the youngsters might feel like romantic characters from stories of old, despite the humdrum surroundings.

▶ SIMPLICITY

As we have seen throughout this book, the simplest way to communicate an idea is usually the best; every extra element you include presents more opportunities to confuse, dilute or even contradict your message. Have the confidence to rely upon the simplicity and potency of the artists' pencil as a tool of invention, imagination and communication and you will not go far wrong.

Remember that this book is only a starting point, a humble introduction to the infinite scope of imaginative art – but I hope that it has helped to fuel your creative spark and that you will feel encouraged to further explore the many magical possibilities that drawing holds for you.

Index